TRANS NEW YORK

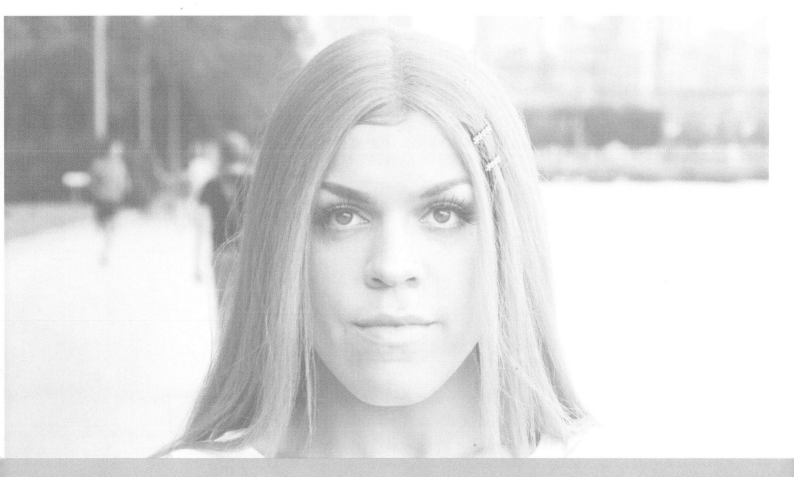

TRANS NEW YORK

PETER BUSSIAN

FOREWORD BY ABBY CHAVA STEIN

APOLLO
PUBLISHERS

Trans New York

Copyright © 2020 by Peter Bussian

Apollo Publishers books may be purchased for educational, business,
or sales promotional use. Special editions may be made available upon request.
For details, contact Apollo Publishers at info@apollopublishers.com.

Visit our website at www.apollopublishers.com.

Published in compliance with California's Proposition 65.

Library of Congress Cataloging-in-Publication Data is available on file.

Print ISBN: 978-1-948062-56-5
Ebook ISBN: 978-1-948062-57-2

Printed in the United States of America.

FOR ALL OF THOSE
SEEKING THEIR TRUTH

CONTENTS

CONTENTS

8

FOREWORD BY
ABBY CHAVA STEIN

I like to joke that while I was raised in modern-day New York City, it felt more like I grew up in an eighteenth-century Eastern European enclave. Seem like a contradiction? That's the power and beauty of New York: my birthplace, hometown, and the city where I have spent most of my life. New York allows communities—in my case, the ultra-Orthodox Hasidic Jewish community—to not only survive with their unique cultures intact, but to thrive in the midst of a diverse array of life.

In my life, I have seen many changes, and have been through many transitions. I have lived lives that are seen as polar opposites: male and female, religious and secular, uneducated and as an Ivy League student, presenting straight and as part of the LGBTQ community. However, at the end of the day these lives did not contradict each other, especially within the context of New York's conventions. The same New York that is the home of the biggest Hasidic community in the world is also the home of the biggest transgender and queer communities, and quite frankly, these communities are drawn to New York for the same reasons.

A few short weeks after I came out as a trans woman—on November 11, 2015—I received an email from a New York magazine journalist with the subject line, "Talk to Me for New York Magazine Story?" During that time, I was in a whirlwind. I was the first Hasidic person to ever come out as trans, and media outlets and producers were running me down for interviews. After having done pieces with the New York Post, the Daily Mail, and The Forward, and having scheduled filming dates with CNN and Fox, I was not exactly in the mood to do another interview.

I opened up the email anyway, because, after all, it was New York magazine. It read: "We'd love to do a story on you 'in your own words' for our upcoming Reasons to Love NY issue. . . . We'd like to point out that even though you are facing rejection from the Hasidic community, you're finding both Jewish and transgender communities."

I was interested. Every piece so far had covered the same angles: exoticizing and/or demonizing the Hasidic community, and sexualizing the experience of trans women. This seemed like a new and interesting take.

We set up a time for the interview, and I readied some talking points in my head: *As a child in the Hasidic community I never felt like I was living in New York; but now, I couldn't think of a better, more open, and more progressive place to live in as a trans woman.* After all, leaving the Hasidic community and transitioning is in every way like immigrating to a new country (with the added privilege of documented citizenship). There's a new language, radically new culture, new food, new brands, and new clothes. My message was clear: *New York sucks when you are Hasidic, but it's beautiful when you are trans.* This was how I felt at the time.

As the interview went on, the journalist asked about being Jewish in New York. I like to stay positive in my interviews and didn't want to talk about the negative aspects of Judaism here, so I focused on the Jewish communities I had become a part of after I came out. In addition to being home to one of the biggest Orthodox communities in the world, New York City is also home to the biggest progressive and Reform Jewish communities. In numbers, New York City proper has more Jews than any other proper city in the world, and more Jews live in New York now than have lived in any individual city throughout recorded history. In the immediate aftermath of my leaving the Hasidic community, I rejected Judaism altogether—I like to say that I had Post-God Traumatic Disorder. After two years, however, I fell in love with the diversity and beauty of the progressive Jewish communities New York has to offer.

One place that I have really connected with is Romemu, a Jewish Renewal community on Manhattan's Upper West Side. Romemu is one of the most welcoming, radically inclusive communities I have ever encountered, religious or not. I became a member in 2014, after I left the Hasidic community but before I came out as trans. Among the first things I picked up after joining were that gender, in any expression, has no impact on one's place in the Romemu community, and, at the same time, all gender expressions are visible and welcome. Romemu was one of the first places I met trans Jews and saw LGBTQ Jews being fully integrated in the broader community. In 2016, after I came out, I even had my very own Bat Mitzvah and naming ceremonies—aptly named "A Celebration of Life in Transition"—where I was not just fully accepted as a woman, but celebrated.

I also found a home in the Columbia/Barnard Hillel, which I was introduced to after I started school at Columbia University in the fall of 2014. Hillel offers a Jewish community for students and is the biggest organized student group on their campuses. It was like a buffet of Judaism, with three or four different kinds of Shabbat services weekly—Orthodox and egalitarian, services with choirs and those with musical instruments, traditional and alternative. There were engaged students who grew up ultra-Orthodox, and students who didn't grow up Jewish at all. Hillel introduced me to the beautiful, rainbow tapestry of American Jewish life, a diverse culture that reflects the diversity of New York City as a whole. Quite frankly, most of the songs, culture, and lingo of modern American Jewry I know today, I learned at the very place where my parents were convinced I would grow to reject Judaism altogether: secular academia.

So, when I met with the *New York* magazine journalist, it was at a time during which I'd found joy in New York's progressive and inclusive spaces, and I spoke very highly of the city and what it has to offer for Jewish LGBTQ people. As time passed, though, I became increasingly aware of the challenges.

New York City, like any place in the world, isn't a utopia. While New York City was one of the birthplaces of the movement for LGBTQ rights, I've learned through experience that homophobia and transphobia are still very present and even flourish here. But things are improving on this front. And while leaving a cult-like community isn't easy even in New York City, this, too, keeps getting better. In fact, New York City is home to the largest, most engaged community of former fundamentalists in the country.

I also learned that the city with the most Jews in the world isn't free of anti-Semitism, but so many citizens, Jews and allies, keep fighting hate with love. In fact, New York City is the base for a wide variety of interfaith groups working to end hate through education and restorative justice. And while I learned the hard way that sexism in many forms, including sexual harassment caused simply by walking down the street as a woman, exists here as well, so many national feminist movements started here and continue to thrive. In fact, New York City is the city that Tarana Burke, the founder of the Me Too movement, calls home.

Yes, we are a city of contradictions, but our contradictions help us prosper. The exact same features that pushed the Hasidic community to settle in New York City—the diversity, the colorful streets, and the freedom—are what allowed me to survive gender dysphoria and find success, community, and love. After visiting over twenty-five countries and over one hundred cities around the globe, New York City is still my only home—my past, present, and future.

I might need to rethink my joke about where I grew up culturally, even though it has already been codified in the introduction to my book, *Becoming Eve: My Journey from Ultra-Orthodox Rabbi to Transgender Woman*. I wasn't raised in eighteenth-century Eastern Europe. Rather, I was raised in a community that glorifies a mythical eighteenth century, something it can only do *because* it exists in twenty-first century New York City. And at the end of the day, my being raised Hasidic is as much a part of my identity as a New Yorker as my being trans. New York, with its manifold people, neighborhoods, and opportunities, allowed me to embrace my own contradictions.

I joined the trans community online and on social media back in 2012, but I didn't come out until three years later, and I didn't start attending in-person support groups until a few months before that. After I came out and was ready to share this with the world, I started writing in an online forum for trans people called Susan's Place. Through Susan's Place I befriended a trans sister—I will call her "Emily"—and we became close, spending hours every day texting and chatting.

In one of our first conversations, Emily told me about her job fundraising for the launch of an LGBTQ support group in the Deep South; the support group would help transgender youth struggling with their mental health. Emily explained to me that once she gets people to listen to her—she tells them she's trying to help teens (who are already out) and illuminates the struggles on all fronts that come with being trans—they want to help. One of the biggest problems she faces is that most people in her city know little to nothing about trans people, with some who have never heard before that trans people exist, so she has to begin by informing them.

To me, the fact that she encounters many people who don't even know that trans people exist isn't surprising at all. I didn't know that trans people exist until I was twenty. I knew that I was a girl who was being raised as a boy, but I thought I was the only person in the world with that experience. It was only when I went on the internet for the first time, an act forbidden in the community I was born into, that I learned that other trans people existed. I was not the only person in the world; there were millions of us.

A few years after Emily and I began chatting, I finally met her in person, at the 2016 Philadelphia Trans Health Conference. After exchanging greetings and hugs, we got to talking about her job. She shared how her organization had successfully hired a few people to run the programs, and that it had paired up with a local youth shelter to help trans youth who had been shunned by their parents—a common reality, unfortunately, especially for trans people who come from religiously conservative homes (my parents also shunned me when I came out to them). Emily was fired up about all that they had accomplished, and all that they have planned for the future.

When I questioned whether Emily was still doing fundraising and had to continue to enlighten people that trans people exist, she chuckled and told me: "It's such a different world now. Now we mostly have to focus on reaching the people who are already supportive, or at least aware of the struggle trans people face. There are so many more supporters now!"

I asked what she meant by this and how we could be in "a different world" after only a few years. She said that our earlier conversation was before trans people were all over pop culture: before *Orange Is the New Black*, before *Transparent*, before Caitlyn Jenner, before *I Am Jazz*, before *Sense8*. I wondered how I'd missed this new reality. Our conversation reminded me how important it is to raise awareness, create visibility, and share our stories.

Between 2012 and 2016, the world changed for trans awareness at an unprecedented pace. Trans people were represented in TV and film—and not just as punch lines, but as real people, with real stories, and often played by trans actors—and print media and news outlets began publishing coming-out stories and features with headlines like "Family of

Trans Person X Speaks Up for Trans Rights." Cities across the country started passing GENDA (Gender Expression Non-Discrimination Act) bills in different forms and at a speed that surprises me to this day (I studied public policy).

Obviously, culture as a whole and people's long-held beliefs and dogmas do not change overnight, and leaders are needed to guide the transition. What we've accomplished over the past few years was only possible thanks to the Stonewall riots spearheaded by trans women of color, and to people like Audre Lorde; my personal role models Jenny Boylan and Kate Bornstein; Leslie Feinberg; and so many other pioneers who paved the way. But we can certainly point to one thing that created the massive push toward trans acceptance in the past few years: the proliferation and publication of personal trans stories. It is easy for people to misunderstand and even hate an idea, a concept. It is a lot harder to hate a human being, especially if you know their story, their journey. Of course, people can still be hateful, but if they know about the struggles of their fellow humans, the chances that they will accept and love them are much higher.

For far too long, people spoke about us without including us in the conversation. For far too long, people spoke of us as objects as opposed to fellow people. For far too long, people sexualized us, as opposed to seeing us fully, body and mind. For far too long, people created a "one size fits all" narrative, as opposed to dealing with the complexity that is humanity. For these reasons, when Peter reached out to me about his work photographing trans people in New York, I was enamored right away. Trans visibility, and more specifically, trans people's stories being shared in a positive light, is possibly the single most successful route to the full acceptance and celebration of our community. Studies have shown that those who get to know trans people, whether personally or through their stories, are more likely, many times over, to support transgender people and trans rights.

Peter's book is a platform that allows us to tell our stories, our struggles, and our journeys. We have taken large steps toward breaking down harmful stereotypes and outdated notions of trans people, but there is still so much work to be done. Peter's work in this book marks another milestone in that direction. By combining the experience of living in New York

City—a place so colorful and vibrant, and yet so humanely complex—with the experience of being trans—an identity so colorful and vibrant, and yet so humanely complex—he continues the critical work of shedding light on, and celebrating, transgender lives.

Just a year after I came out, I had already amassed a long list of media engagements, including in film. I was on a Showtime docuseries called *Dark Net*, and I have done short documentaries with media like CNN, FOX, NBC, the Huffington Post, and more. I do not think that the producers who approached me were interested in me because I was the "best" or most accomplished trans person they could find, but rather, because my story seemed exotic. My before-and-after pictures are more visually striking than most—though by chance of birth and through no credit of my own.

In January 2017, a mere fifteen months after I came out, I was invited to present at Limmud NY, one of the biggest annual Jewish conferences in New York. One of the seven sessions I gave was called "My Story in the Media." In my presentation, I showed about a dozen videos I had filmed with a host of different networks, and used it as an opportunity to talk about the good, the bad, and the neutral aspects of media coverage. At the end, there was an open Q&A period.

A young, visibly queer girl raised her hand and asked, "Why in the world are they so obsessed with your makeup?"

I'm not sure how I missed it until she asked. Almost every filmmaker and every network producer had asked to film me putting on makeup in one way or another. I have been wearing makeup daily, out of my own choice, ever since I came out, and I'd never thought much about this request.

"I guess they find it exotic," I responded. "Though when I think about it, there is definitely the old theme of sexualizing trans women. As if to suggest that our value depends on how feminine, or to put it more exactly, how stereotypically feminine, we look."

Ever since the question, I have noticed how common the filming of trans women putting on makeup is. The vast majority of trans people in the media are those who "pass." For trans women, this means adhering to conventional Western standards of female beauty. In many ways, the media treats trans women like they treat all women: expecting them

to meet unrealistic, stereotypical, and often abusive beauty norms. If you don't fit the bill, your chances of being covered in the media are slim.

I love femininity, and I enjoy embodying it. Don't get me wrong, there is nothing wrong with wearing makeup or wearing pink clothes; embracing a typically "feminine" style can be empowering. Yet, I can't help but wonder if I would have had the same worldwide exposure if I chose not to display my femininity the way I do. When I consider the hundreds of thousands of people I get to speak to in person; the hundreds, if not thousands, of personal stories I get to hear; and the tens of millions of people I get to reach through the media thanks to my sharing my story, I do not regret for a second the work I have been doing. I just need to be aware of the privilege that comes with my traditionally feminine presentation. I need to pay attention to it, and to do all I can to bust these stereotypes.

Busting stereotypes is another accomplishment of Peter's work and why I love *Trans New York*. In these pages you will find more than fifty authentic portraits of real people. Real trans people, real New Yorkers. They're not caked in professional makeup or posed in studios. They're just people, as they always are, contradictions and all, sharing inspirational quotes, details of their lives, and personal stories. I have no doubt that this book will be life changing for so many readers—trans people, LGBTQ people, and cisgender and straight people alike. *Trans New York* is a jewel in the crown of positive trans stories, a jewel in the crown of New York City.

ESSAY BY
POOYA MOHSENI

When I was a child, I wanted to grow up to be a beautiful woman. I wanted to be seen, be liked, and feel confident in my skin. But for a transgender woman growing up in the 1980s in Iran, that was a tall order. A very tall order! I was lucky if I wasn't completely trampled on, harassed, or even worse. As difficult as the path may have been, I have traveled my journey to this moment. I came to New York City. I transitioned. I graduated college. I was able to have full-time jobs in the design world. I was allowed to follow my dreams. Maybe in a smaller way or at a slower pace than my non-trans, non-immigrant counterparts, but I was able to move forward, make mistakes, recover from them, and move forward. I am here, alive and well, because I was fortunate enough to survive the obstacles along the way.

Many others like me have not necessarily been as fortunate. There are trans people who have never had any kind of support from anyone in their family or immediate circle. There are those who never grew up to see themselves as they truly are. Some stay fearful and are never able to shine as their true selves, and there are those who dared to question the worlds they lived in and paid with their lives. That is too high of a price to pay for just existing, but it is the reality for many trans and gender nonconforming individuals around the world. That is the price of being different.

I can tell you that I felt afraid as a child telling people how I felt or how I wanted to be seen, but there were a few people who saw me, even accepted me, despite the fact that we didn't have the right language to talk about it. I can go on to say that I was bullied at school for being different, but I survived it, relatively unscathed. No, my parents didn't jump for joy when our therapist told them that I was trans. I was sixteen and it was 1994. We had never even heard the term "transsexual" until that day. And yes, they did try to find a "cure"—that was not fun, to put it lightly—and I did try to commit suicide, multiple times. I was also assaulted, and I was almost killed on a number of occasions. But, I didn't die. And my parents, despite their serious reservations, fear, and sense of personal guilt, did not throw me out, like many parents of queer individuals have and still do. My parents tried to find a way for me to become who I truly am and find a place that would make a new life possible. I was fortunate to have supportive friends and parents

who came around—which allowed me to become who I am today.

When I started transitioning, many people were not kind. They laughed, mis-gendered me. There were photographers who stopped working with me when they found out I was trans. Doors were closed in my face and opportunities were taken away. All because of who I am. But I survived, and am able to tell you my story. Thousands of other trans people have not been as lucky.

I've heard of women, trans and other, who worked the streets and were beaten up by their johns. Movies like *Boys Don't Cry* show how trans individuals are brutalized, violated, and killed. There are trans women of color who are put in prison cells with men, with little to no regard for their safety, because they are perceived as men in dresses. The list of names of sisters who have been lost to hatred and bigotry over the years is long. The "trans panic" defense is still actually used, albeit less and less, in courts, to justify why someone could plausibly kill another person after they realize that the individual is trans, for fear of . . . who knows what. But again, I was fortunate to not be one of those beautiful souls whose journey is cut too short, just because they do not fit society's idea of "normal." Being mocked, ridiculed, demeaned, assaulted, or beaten to death is not news in my community, no matter what part of the world we're from. Yes, it may be better in Norway than Uganda, and certain laws may be slightly more favorable in New York than in Michigan, but the fight for survival and personhood is very real and extremely serious in the queer community, and even more so for trans women everywhere.

But why do I keep talking about the bad things and the dark corners of our lives when I can talk about rainbows and unicorns, love and truth? I go into detail about the grim realities of being trans and gender nonconforming, or different in general, so we can appreciate how special it is to be seen and to see others like us, living in unabashed truth. Only if you see dark, can you appreciate light. The fact that I get to be openly trans, move forward in my life, affirm my LGBTQ+ siblings, be affirmed by them, and acknowledge that we are a family is special to me, because I have experienced a world where none of those things existed. I know what it's like to feel isolated as a teenager, and as an adult.

As an advocate and a "community mom," I see it as my responsibility to make sure that our younger generation has a better, more loving and affirming view of themselves, their identity, and how they relate to the world around them.

Being featured in this book alongside many other people who are of different ages, come from different backgrounds, and express themselves in unique ways is more precious to me than I can explain. In short, it gives me hope. It gives me hope that we are celebrating diversity in a marginalized community, in a city that is built on variety and thrives because of it. Being in this book—out, proud, and open—among my beautiful siblings who have fought adversity, prejudice, hatred, dysphoria, isolation, and worse is indeed a dream come true and a privilege. One that I do not take lightly; one that I cherish from the depths of my soul; and one that gives me hope for a brighter, more inclusive, and more loving future for all of us.

I started my journey toward becoming a man of transgender experience later in life than many other trans men do, when I was nearly thirty. I was already steadily employed and had children.

Before coming out as trans I lived as a lesbian woman with what one might call a "butch" or "stud" appearance and demeanor—though I never used those words myself. I am lucky that I never experienced any negativity for the way I looked and lived. In fact, things had always been pretty good. I'd never had major difficulties or trauma. Growing up, I attended only private schools, and I held down all kinds of odd jobs in my neighborhood. My dad was a driver for many celebrities, and my uncle was a member of the FDNY (Fire Department of New York City). I had close friends and family members. I felt supported by my community.

But things changed when I began my transition. People stopped understanding me and began to treat me differently. The community I had navigated for most of my life turned its back on me, as if I was doing something wrong when all I was doing was figuring out how to be the most authentic version of myself. When this happened I didn't know where to turn. I didn't feel welcome in my community, but I also didn't feel a connection with the most easy-to-find trans community: cross-dressers, drag kings and queens, and people who referred to themselves as "trannies." It wasn't that I needed to fit in somewhere, I just wanted a sense of community.

This was the first time I was truly disappointed with the people in my life, and many more times were ahead. I've learned that with some people it doesn't matter how well you've treated them; they'll tear you down the first time you say no to them, as if you've never done anything for them before. I've also learned that not everyone who says they support you supports you how you need it; this was a major life lesson.

But I've also had wonderful experiences with people. Since transitioning, I've met many great people and done many things I'm proud of. For over twenty years, I have been a peer educator and transgender equality advocate, and a spectator and participant in New York City's underground ballroom scene, where members of the LGBTQ community socialize and compete for titles and prizes in various categories. I created the "trans man realness"

subcategory of the "butch realness" category. In the ballroom scene there are "houses," which function like families, and I am a house father for both the House of Khan and Legacy International houses.

I've also worked as an HIV tester and counselor, and in this capacity learned that many people in the LGBTQ community, particularly men of transgender experience, need assistance accessing education on HIV prevention and navigating resources. In 2019, I was one of the coproducers of a part of the AIDS oral history program "Surviving Voices," which was launched by the National AIDS Memorial and the HIV Story Project. My work explored the impact of the AIDS pandemic on the transgender community, and the videos and interviews in this collection shed light on the experiences of transgender women and men as well as nonbinary and gender nonconforming individuals with HIV/AIDS, and honor the contributions of the members of the trans community (both HIV positive and HIV negative) to the fight against AIDS.

As a peer educator, I have been a role model to other trans masculine individuals, promoting healthy and positive ways to transition and encouraging other men of trans experience to be their best selves. I tell them it's okay to not know all the answers and to ask for assistance during what can be a very lonely and difficult journey to knowing what's right for your body and mind. And as a community builder with other trans masculine leaders in New York City, I have helped build brotherhood among trans men here and around the country. I was also on the frontlines of the fight to legalize marriage equality and pass GENDA [the Gender Expression Non-Discrimination Act], and I watched the Empire State Pride Agenda dismantle, citing fulfillment of its goals, after New York's Marriage Equality Act passed and legalized same-sex marriage.

Another role of mine is as executive director of Princess Janae Place, which I founded in 2015 and which uses the name of my chosen mother, Princess Janae Banks. The organization helps people of trans experience transition from homelessness to independent living, and encourages them to maximize their full potential. It is often a critical referral source our members use while securing housing, and can also help people access rehab programs for substance abuse, mental health

services and other healthcare, legal assistance, and job training and placement programs. It is a safe space for people of trans experience to connect with a community, access gender-affirming support, and engage in educational and recreational activities. I believe in supporting, providing for, and assisting people in need, and I use my connections to help people succeed.

My most humbling and proudest accomplishment to date is my receipt of the title of Mr. Trans New York USA 2020. I consider this symbolic of my dedication to eradicating stigma, violence, and phobias against all trans people. After everything I've been through, I am so thankful to be alive, and I am grateful that this leadership role, among others, allows me to tell my story. I hope it is inspiring to people in need.

I underwent my first gender reassignment surgery (top surgery) in 2007 and my second (bottom surgery) in 2016. These have changed my life immensely, allowing me to be more comfortable with the body I inhabit, but I've had many complications related to the second surgery and it sparked a series of successive surgeries—to the point that to date,

I've had nine surgeries, and I face the potential of still having to have many more. The surgeries and complications cause me anxiety, but I've tried to redirect this excess energy toward doing good, and have become a mentor and surgery buddy to many trans people undergoing physical transitions. I share my experience and talk them through various potential outcomes, so they know what to expect and what to do or not do after their surgeries.

As a result of my surgeries, I now have a fully masculine appearance, and this coupled with my sexual preferences leads to me being perceived as a cisgender male. This is a blessing in so many ways, creating a feeling of accomplishment, but it's also a curse. When you can "pass" as your new identity without anyone questioning it, you no longer stand out as you used to, and this can have the unanticipated result of making you feel invisible. Being "passable" doesn't mean you're not continuing to go through social and emotional transitions, and don't still need people to support you. These challenges are all-too-often faced alone.

At every step of my journey, the importance of community and personal connections has been

enforced. I've learned that you can only assist those who are ready to receive help, but I've also learned how important it is to reach out and try to help. My personal mantra when it comes to helping people is: If not now, then when? If not me, then who? Be the change the world needs today for a better tomorrow.

ESSAY BY
GRACE DETREVARAH

In 1983, I arrived in New York. In Detroit, my life was that of young person struggling with identity and searching for a place in a world that wasn't tolerant of a flamboyant male-born child. Therefore, I ultimately would become radical to my family and the community. New York was where I would begin to live out my life as I am today: as a black woman of transgender experience. For me, being trans is to first know in one's heart, mind, and existence what you are. I am a woman.

I would go through years of various levels of transitioning. During my early years in New York, I spent five years living as a drifter. I was formally trained in ballet and dance while in Detroit, and in New York I fell upon a famous dance choreographer who I lived with for two years as his housemate, friend, and lover. He ultimately died of complications of HIV. After his death, I began a troubled spiral of living recklessly, falling back into criminal behavior. I lived in Los Angeles, Miami, and Toronto through most of the nineties.

When I returned to New York, I had a short-lived career working as a stagehand with the Actors' Equity Association, but I eventually lost the position and career due to my secret drug use. This sent me to jail for a decade, and ultimately to the big house: prison.

While in prison I was forced to focus on my life. In all my stationary time while incarcerated, I began to educate myself. I accomplished my paralegal certification and graduated from Cayuga Community College through the prison college program with an associate degree in general education and a minor in human services. I would also become radically instrumental in advocating for prisoners' rights at various New York State Department of Corrections and Community Supervision (NYS-DOCCS) facilities. I wrote on topics like education and reentry programs in journals, newsletters, and media through correspondence with LGBTQ organizations and others.

I became educated on HIV/AIDS by becoming a facilitator with Prisoners for AIDS Counseling and Education (PACE) at the prison where I was held. I would become infamous with prison officials for events I organized for World AIDS Day.

I was released in 2016, and my life took off in November 2017. I was invited to give a presentation on name change and proxy laws for LGBTQ individuals at the National Black Leadership Commission on AIDS (NBLCA), giving me my first paycheck. This would lead to a ten-month internship with NBLCA. I would

go on to intern for the Sylvia Rivera Law Project, the American Civil Liberties Union's LGBTQ rights division, and the New York Transgender Advocacy Group, which would lead to my current position with the Osborne Association (OA)—a social justice organization providing reentry services for people with histories of incarceration, HIV, and mental health diagnoses.

In 2017/2018, the Osborne Association created an LGBTQ component to serve LGBTQ participants at OA and in the community at large. I've been an important asset to this with my experience, dedication, and love for the LGBTQ community.

During all of my work at Osborne, the New York City and New York State LGBTQ and black and Latino communities began to call upon me to speak at various venues. I spoke at the 2019 Philadelphia Trans Wellness Conference on a joint panel with the State of New York's Legal Aid Society, as well as on panels at the National Transgender Health Summit in Oakland, California, and at the first National Trans Visibility March in Washington, DC.

In 2018, I filmed a short documentary called *Transformation Conversations*. In the same year, I was honored with a city council citation from Bronx Councilwoman Vanessa L. Gibson for my advocacy work.

In 2019, I spoke at New York University's School of Law, the John Jay College of Criminal Justice, Swarthmore College, and Lehman College. I also spoke on Netflix's pending *Bitches Who Lunch: 1980s AIDS*. I was there.

I was featured in *The Unleashed Voice* magazine's December 2019 issue and honored by Pride & Power (an organization of black and Latino leaders who have joined together to advocate, educate, and marshal resources for the benefit of our black and Latino LGBTQ community) in January 2020.

Since meeting Peter, the photographer for *Trans New York*, I have been inspired and empowered to be a part of this book and project. For most transgender individuals, we are who we are . . . just in a world that may not understand us, and that assumes various things about us. Hopefully the photographs and interviews will tell stories that are similar enough for anyone to recognize. We are plain, glamorous, free, employable, students, teachers, sex workers, advocates, clergy, neighbors, and citizens of the human race.

INTRODUCTION BY PETER BUSSIAN

I've photographed people all around the world and spent more than twenty years working in developing countries, including during periods of war and famine. If there is commonality to my images, it is their documentation of the innate resilience of people as a species and how similar we all are at our core, while at the same time being wonderfully unique as individuals. I work to capture moments—love, laughter, loss—to break stereotypes, and to expose injustices.

Last summer I went to the New York City Pride March to take some pictures. At home that night I scrolled through them and one photograph stood out—a black-and-white image of a transgender couple. They were standing side by side in a doorway, dressed in ethnic North African clothing and jewelry. Both stared directly into the camera—one man's body stood straight, entirely facing forward, and his partner's body leaned into his. They seemed unusually secure in themselves, as if they had the kind of knowledge of self, of their identities, that some of us spend our whole lives searching for; or at least that's what the image led me to believe. I wanted to know more about them, and I sent the photo to

my publisher Julia Abramoff, who had edited my previous book, *Passage to Afghanistan*. She loved it. We discussed it and tried to nail down why it was so striking, so mesmerizing. Was it what we perceived to be confidence, and is that something all transgender people have after finding themselves? Or was it that it's rare to see transgender people captured on film with such earnestness—an effort to share who they are and not a stereotype or caricature, or who the media wants to portray them as?

We began to wonder what it would be like to create a book of photographs and stories of transgender people. Would we be able to answer these questions in the process? We questioned how we could break down stereotypes, and how we could celebrate similarities and differences. It was important to us to let trans people speak for themselves, not to speak for them.

Over the next five months, I met with, interviewed, and photographed more than fifty trans and gender nonconforming New Yorkers. The sample was totally random, but ended up being about 50 percent trans women, 30 percent trans men, and 20 percent nonbinary people. I found

most people through personal connections or on Instagram or Facebook. Contrary to common negative stereotypes—like being unemployed, homeless, and/or sex workers—most of the people I interviewed have jobs and places to live, and many are thriving. However, it is still noteworthy, and I'd be doing an injustice if I glossed over it, that compared to the larger population there is a disproportionately high rate of homelessness, unemployment, and forced work in the sex industry that stems from desperation among the trans community. And within these segments, the people suffering are disproportionately trans women of color. It's impossible to avoid connecting the dots of dire circumstances with the persecution and prejudice that trans people face nationwide and in countries around the world—which, all too often, tragically leads to death by violence or suicide.

Many of the people I reached out to asked why I was making this book. The question was usually asked out of curiosity, but sometimes out of distrust, and this is entirely understandable. The trans community is frequently exploited for their stories, which are now prominently featured in media around the world, including magazines, newspapers, and fiction and nonfiction TV shows and movies. Some people were concerned that I was trying to cash in on them. Gaining trust was slow at first but became easier once they saw that the photographs were portraying them in an honest and forthright way, and focusing on the positive. I also had several "influencers" whose support I was fortunate enough to gain and who sanctioned the project. I am grateful for this.

Some of my motivations for creating this book were personal and driven by dramatic life events over the past few years: the birth of my children—today, five-year-old twins who are not yet very defined by gender roles and expectations—and the death of my parents and brother, who were pillars in my life and whose loss made me question many assumptions, including gender. I also wanted to explore the huge changes I've seen in my lifetime in regard to how people define and perceive themselves. It is increasingly evident that people are defined by who they are in their hearts and minds and how they are wired neurologically. They are certainly not defined by the anatomy they were born with and the gender they were assigned at birth.

The interviews I conducted for this book support my belief that male and female exist in all people, that gender is on a spectrum, that identifying as male, female, or nonbinary is based off a personal truth, and that where a person is on that spectrum may be static, or can change in their lifetime, even within a single day. Trans people are no different than anyone else except that the gender they were assigned, and frequently the physical body they were born into, does not align with their true identity. Sometimes people know this from childhood and sometimes they only realize it later in life. Sometimes the consequences are remarkable and liberating, and sometimes they're devastating. I've come to understand that being trans is not about choosing to be someone else; it's about finding yourself.

When I photograph people I feel it is my job to try to capture their souls—to get beyond the surface and allow their internal light to shine through. I thought photographing trans people might be challenging in this regard, since sometimes who they feel like they are on the inside is not who they look like on the outside (this is true of all people, by the way). But capturing the physical representation of who they are inside was a lot easier than I expected it to be, because most of the trans and gender nonconforming people I photographed are very in tune with how they feel about themselves on the inside and also how they are perceived on the outside. In short, they are more self-aware than most people, so photographing them was relatively easy.

Some of the people in this book were born in New York City, and others moved here to, like most other transplants, pursue their dreams. For trans people this often starts with simply being able to be themselves. Every person I interviewed was unique, and each shined with an inner strength and self-direction. I believe this is tied to the fact that in most cases people had to rely on themselves, without any hand-holding, to make the transition. I heard many stories of immense challenges and hardships, usually beginning within the person's family—and often including physical danger. It was made clear that trans people are hungry to live in a society that accepts them on their own terms. Just like everyone else, they desire respect, if not understanding.

This book would not have been possible without the honesty and openness of the people I spoke

with. Over and over again, I found myself inspired by their integrity and strength, and many of them have become my friends. One of the most striking aspects of nearly every person in this book is their sheer joy for life; one of them told me, "Anything in life is possible after transitioning because this is the most difficult thing a person can do." I am a very proud supporter and ally of New York City's trans community, and while I hope this book also reaches many people outside that community, they are the heart of it. They have a colorful tapestry of stories, experiences, and personalities, and I am so appreciative of the kindness and support I received.

In some ways the persecution of trans people is just the tip of the iceberg of interrelated issues that include homophobia, misogyny, racism, and white privilege. Rights for trans people and other members of the LGBTQ community, women, and people of color and other minorities threaten the historical power structure, and this makes some people uncomfortable. Persecution and prejudice stem from discomfort. I hope that by sharing the stories and images of a small sample of transgender people, I can contribute to breaking down some of the fear and negativity.

The New York City element of the book has caused me to draw parallels between how trans people today and immigrants both today and historically have come to New York City seeking a better life. To this greatest and most accepting of cities have come Jews from Eastern Europe, African Americans from the South, Irish during the potato famine—people from every country on Earth and every small town in America. There is no city that represents what America is about more than New York City, and many of the people I interviewed said that the city was a big part of their ability to thrive—and in some cases to simply survive. America's promise to the world is individual freedom on a level that no other country has ever achieved. Defining one's own gender is the ultimate in individual freedom, and therefore trans people to me represent that highest ideal. Regardless of what political party or religion people identify with, our common shared values as Americans and as defenders of human rights around the world require us to protect and respect trans and gender nonconforming people, as is necessary for all people.

ABBY C. STEIN

NAME (FIRST AND/OR LAST): Abby C. Stein

HOMETOWN: Williamsburg, Brooklyn

CURRENT NEIGHBORHOOD: Upper West Side, Manhattan

CURRENT AGE: 28

AGE AT TRANSITION: 23

PREFERRED PRONOUN(S): She/her/hers

CAREER/JOB: Public policy, author, and educator, ordained rabbi, and co-founder of Sacred Space

RELATIONSHIP STATUS: In a relationship with an amazing woman!

WHAT WAS YOUR PATH TO TRANSITION LIKE?

In brief: I grew up in an ultra-Orthodox Hasidic Jewish community in Brooklyn, one of the most gender-segregated communities in the world. I am the sixth child out of thirteen, with five older sisters. I was raised as a boy, and expected to follow my family's lineage of centuries of rabbis. I was married off in an arranged marriage to a girl at age eighteen, and after finishing my ordination a year later, I started leaving the community.

In 2014 I started school at Columbia University, after studying for two years to learn basic English—my fourth language. I finally came out in 2015, at which point most of my family stopped talking to me.

My first book, a creative memoir, *Becoming Eve: My Journey from Ultra-Orthodox Rabbi to Transgender Woman*, was published in 2019 by Seal Press, a Hachette imprint.

WHAT ARE INTERESTING THINGS ABOUT YOU? WHAT MAKES YOU AS A PERSON UNIQUE?

I am quite obsessed with studying genealogy, my own and other people's. My own family tree is more of a bush, given that my family kept marrying each other, kind of like a royal family. In 2018, I mapped my ancestry, every generation, back to Augustus, the first Roman emperor, at least according to geni.com. . . . The benefit of my nerdy obsession in real life, though, was that I found an entire branch of the Stein side of my family—first, second, and third cousins that now live in Israel and are quite secular—that my family pretty much ignored after the Holocaust because they were not religious. I have connected with them now, and it's great to have a whole new biological family that accepts me and loves me!

(continued on page 132)

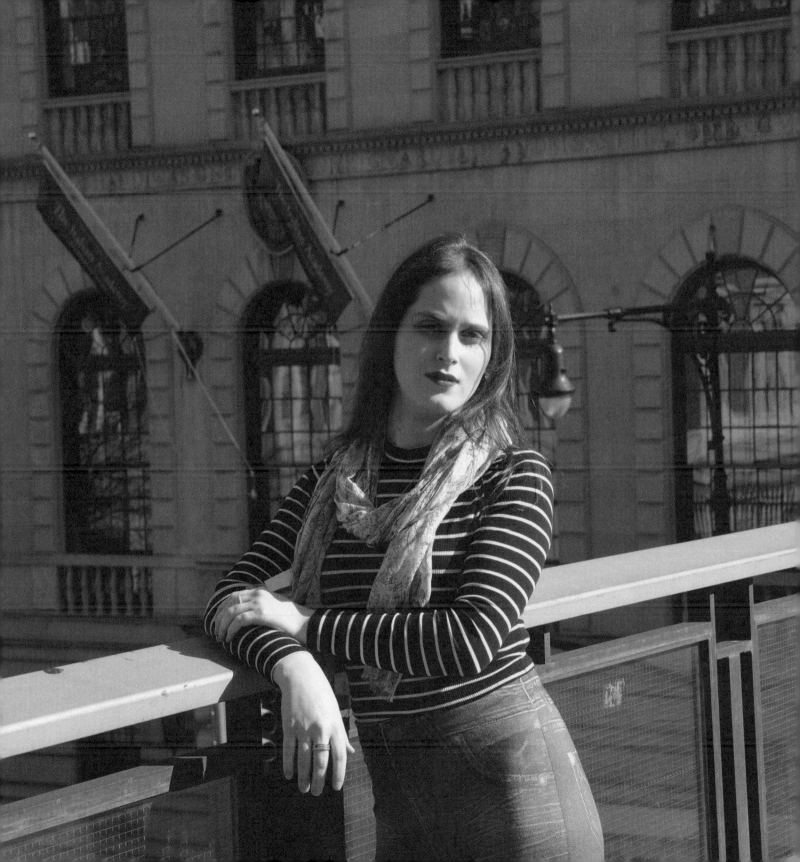

ALANA JESSICA DILLON

NAME (FIRST AND/OR LAST): Alana Jessica Dillon

HOMETOWN: New York City

CURRENT NEIGHBORHOOD: Flatbush, Brooklyn

CURRENT AGE: 22

AGE AT TRANSITION: 19

PREFERRED PRONOUN(S): She/her/hers

CAREER/JOB: Actress/model/waitress :(

RELATIONSHIP STATUS: Single

WHAT WAS YOUR PATH TO TRANSITION LIKE?

I transitioned before hormones had hit that much so it was relatively easy. Transition itself actually felt like one of the most natural things I've ever done. It's been everything apart from that that's been challenging. It's exciting, however, to be coming of age in a time that is more celebratory of transgender people than ever before. I feel as though I'm part of a new age of transsexuals—ones who are confident and dare to be seen, and that's intimidating the crap out of people. Which is so hot.

WHAT ARE INTERESTING THINGS ABOUT YOU? WHAT MAKES YOU AS A PERSON UNIQUE?

I have a very curvy body and am known for that. You learn through this process (transitioning) that absolutely anything is doable—because this is the most difficult thing you can do.

I take pride in how frequently I'm told that someone has "never met a girl like me." There are tons of assumptions thrown on you about how you, as a trans girl, are likely to act. But I'm an artist, an actress, a model, I love fashion and writing, and I'm trying to learn the guitar. People in America don't expect trans people to have souls because all they've seen is Maury Povich's show or Caitlyn Jenner, but I wear my soul on my sleeve every day. It really throws people because they're used to dehumanizing us.

(continued on page 133)

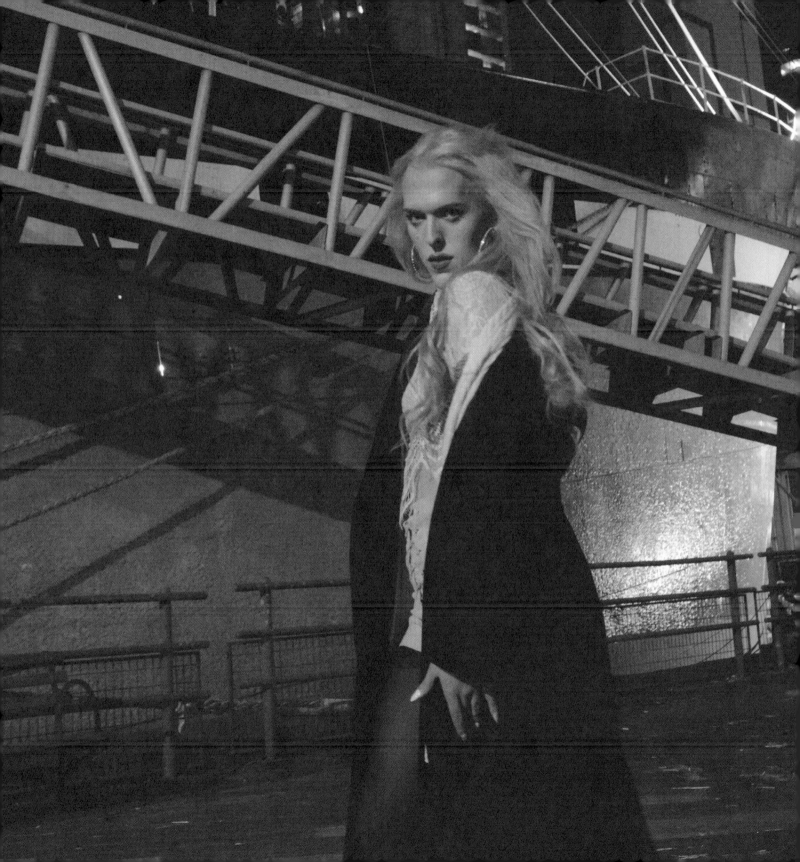

ALEX ROBERTS

NAME (FIRST AND/OR LAST): Alex Roberts

HOMETOWN: Both Jamaica, Queens, and Wallkill (upstate), New York

CURRENT NEIGHBORHOOD: Jamaica, Queens

CURRENT AGE: 20

AGE AT TRANSITION: Started HRT [hormone replacement therapy] at 19, started exploring gender at 16.

PREFERRED PRONOUN(S): They/them (he/him)

CAREER/JOB: Dog walking

RELATIONSHIP STATUS: Dating, single partner

WHAT WAS YOUR PATH TO TRANSITION LIKE?

I had to do it on my own. After my first appointment, my mother discovered that I went through her insurance and requested I not use it for all my gender-related things, as it goes against her beliefs. I'm currently trying to figure out how to get my surgery without it.

WHAT ARE INTERESTING THINGS ABOUT YOU? WHAT MAKES YOU AS A PERSON UNIQUE?

My desire and drive to create meaningful art for myself and others like me. My friends call me a calming and supportive presence. Small facts are that I've learned to play piano, violin, trumpet, and self-taught guitar.

WHAT WOULD YOU LIKE PEOPLE TO KNOW ABOUT YOURSELF AS A TRANSGENDER PERSON THAT MIGHT BE VERY DIFFERENT FROM PEOPLE'S IDEAS OF TRANS PEOPLE?

I'm a masculine-leaning, nonbinary trans person. I rarely define myself as a man and never as a woman, but I may lean toward feminine presenting sometimes. I'm trans in the sense that I no longer associate with my gender assigned at birth, at all, but anyone that may still feel that connection sometimes isn't any less trans (i.e., gender-fluid, and many other nonbinary identities).

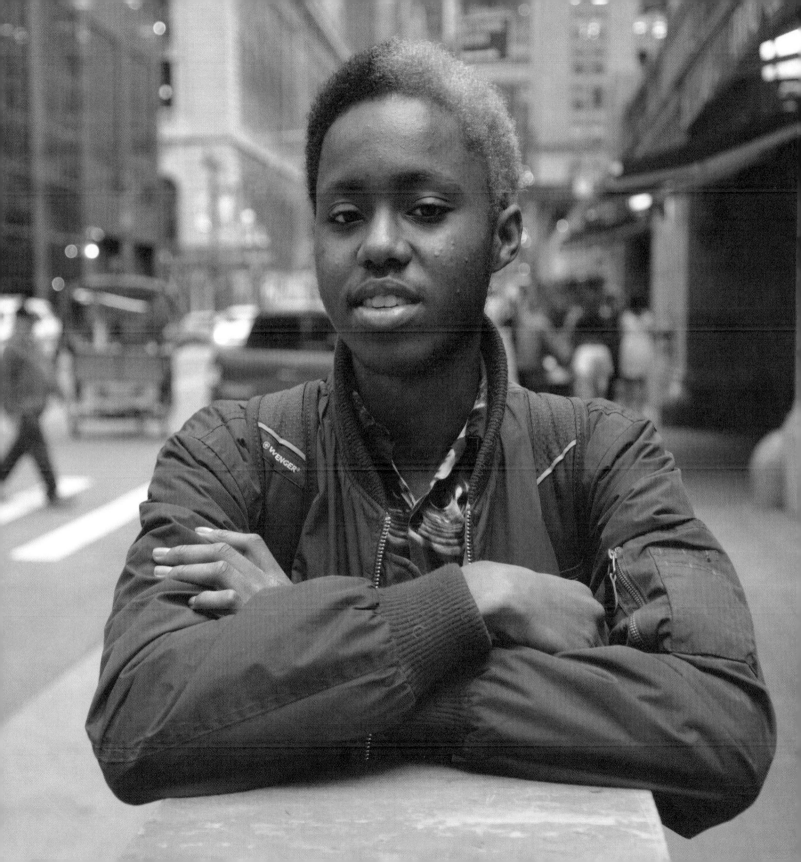

ALEX ZINN

NAME (FIRST AND/OR LAST): Alex Zinn

HOMETOWN: New York City

CURRENT NEIGHBORHOOD: Upper East Side, Manhattan

CURRENT AGE: 20

AGE AT TRANSITION: 19

PREFERRED PRONOUN(S): They/them

CAREER/JOB: Student

RELATIONSHIP STATUS: Polyamorous

WHAT WAS YOUR PATH TO TRANSITION LIKE?

I, for years, have been questioning my gender. I started a medical transition, realized it wasn't for me, and "detransitioned," reaffirming my love for traditionally feminine clothing and makeup. I've only been identifying as femme nonbinary for about six months, but my journey with gender has been long and arduous.

WHAT ARE INTERESTING THINGS ABOUT YOU? WHAT MAKES YOU AS A PERSON UNIQUE?

I'm autistic. I'm in college for sociology intending to eventually get a PhD in sexology. I'm an activist for trans rights, I'm pro-choice in every possible way including pro-drug, sex positive, and pro-abortion.

WHAT WOULD YOU LIKE PEOPLE TO KNOW ABOUT YOURSELF AS A TRANSGENDER PERSON THAT MIGHT BE VERY DIFFERENT FROM PEOPLE'S IDEAS OF TRANS PEOPLE?

That you need dysphoria to be trans. That there's only two genders, or that erasing the genders of other cultures is okay. That sex is binary or that any part of biology is binary. That trans children can't make their own decisions about who they are, or that you're ever too old to transition.

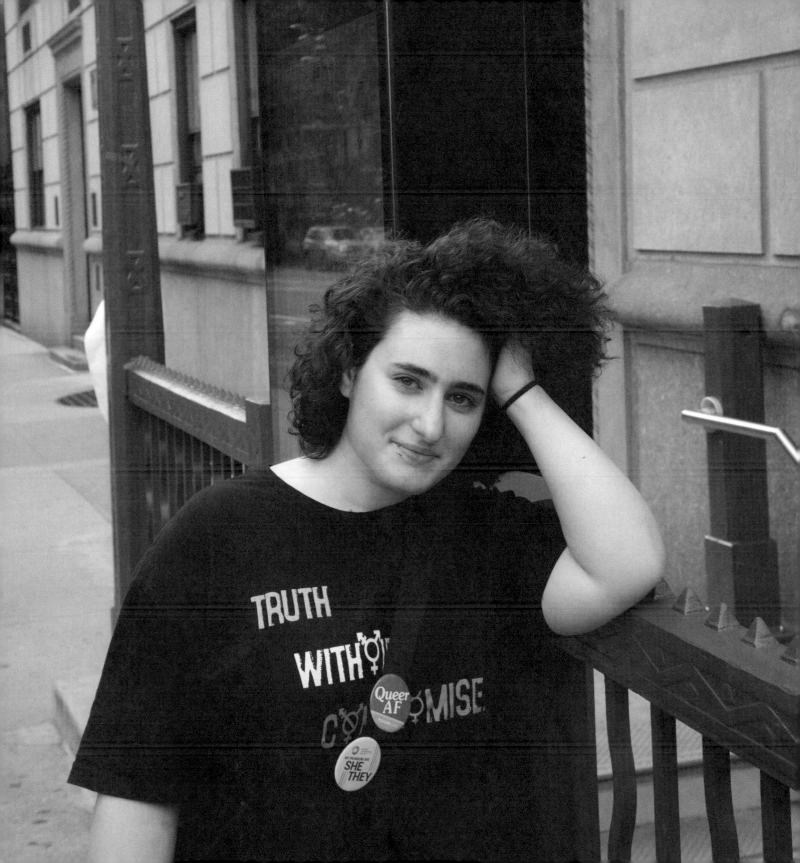

ALISTER RUBENSTEIN

NAME (FIRST AND/OR LAST): Alister Rubenstein

HOMETOWN: Philadelphia, Pennsylvania

CURRENT NEIGHBORHOOD: Queens

CURRENT AGE: 34

AGE AT TRANSITION: 31

PREFERRED PRONOUN(S): They/them

CAREER/JOB: Transgender health program manager, artist

RELATIONSHIP STATUS: Married

WHAT WAS YOUR PATH TO TRANSITION LIKE?

I grew up in foster care and have struggled with the impacts of developmental trauma. One of the most disruptive symptoms has been dissociation. Identifying the feelings of gender dysphoria is very challenging when you are not connected to your body. As I continued on my healing journey, I have started to live in my body more and more. Gender euphoria—like the feeling of utter relief and joy I felt when I tried on my first binder—is much easier for me to identify than gender dysphoria. Gender euphoria has helped me come to terms with my gender identity and medical transition goals.

WHAT ARE INTERESTING THINGS ABOUT YOU? WHAT MAKES YOU AS A PERSON UNIQUE?

I am an artist, an activist, and an incest survivor. I believe that being open about mental illness and childhood sexual abuse is an important means to end the stigma associated with it. I use art as a form of self-care and meditation and also have a small business, The Crafty Queer, where I create trans, queer, and recovery-affirming greeting cards and illustrations. I believe it's important to celebrate LGBTQ and recovery milestones that are often unrecognized by mainstream society.

WHAT WOULD YOU LIKE PEOPLE TO KNOW ABOUT YOURSELF AS A TRANSGENDER PERSON THAT MIGHT BE VERY DIFFERENT FROM PEOPLE'S IDEAS OF TRANS PEOPLE?

Nonbinary does not look a certain way. Femmes can be nonbinary too! I also want people to know that nonbinary people can also be transgender and seek medical transition, even if they appear to present as their assigned gender. We can't make assumptions about how a person identifies or chooses to transition.

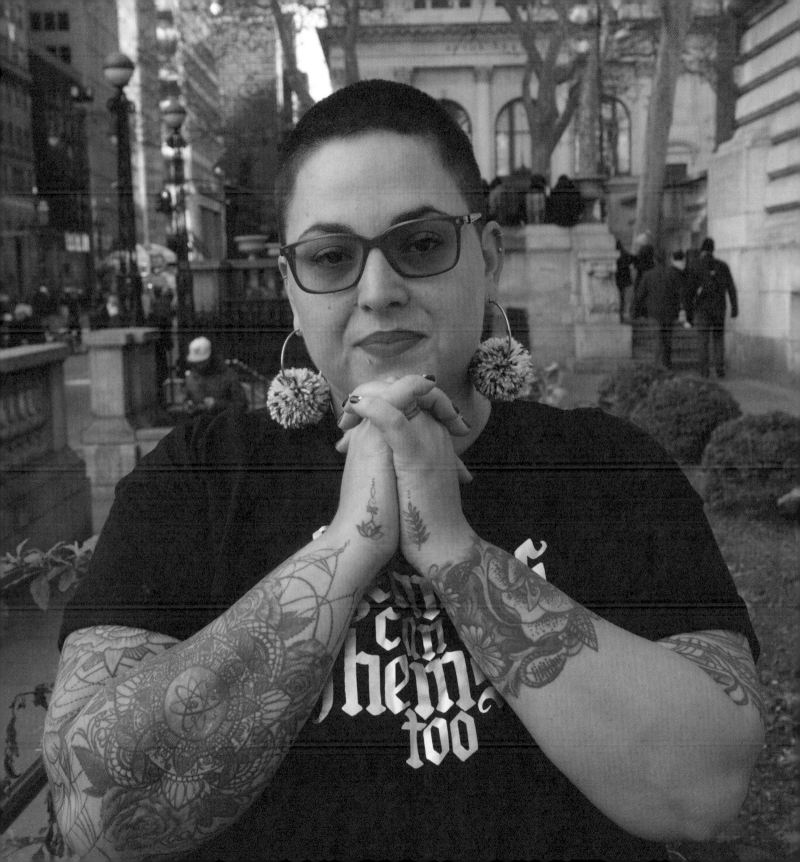

ANGELICA TORRES

NAME (FIRST AND/OR LAST): Angelika Torres
(preferred spelling is "Angelica")

HOMETOWN: Manhattan

CURRENT NEIGHBORHOOD: Bedford–Stuyvesant, Brooklyn

CURRENT AGE: A lady never tells ;)

AGE AT TRANSITION: I personally don't align myself with the word "transition" as it implies that I went from one thing
(or one gender) to the other. I am now, and have always been,
a woman. I prefer to say that I began living as my authentic self/gender full-time at the age of eighteen.

PREFERRED PRONOUN(S): She/her/hers

CAREER/JOB: Actress, model, public speaker, activist

RELATIONSHIP STATUS: Perpetually single

WHAT WAS YOUR PATH TO TRANSITION LIKE?

The path to living as my authentic self began after I was forced by Lisa (my "mother") to cut off my long hair at the age of eighteen. I was dating a cisgender, heterosexual male to whom I'd yet to disclose that I was trans, and by an unexpected turn of events, Lisa found out about it and gave me an ultimatum. I was either to end up on the streets or cut my hair. . . . I reluctantly and tragically chose the latter. After a suicide attempt following the traumatic event when my hair was taken away from me, I was hospitalized, and upon being discharged from the hospital I then moved into an emergency shelter/transitional-living program. It was then that I was finally free to begin HRT (hormone replacement therapy) in addition to taking testosterone blockers. During such time, I was publicly berated with homophobic and transphobic comments every single day I stepped foot outside my door. Words like tranny, faggot, homo, and cocksucker, among others, drowned me like quicksand. I'd worn wigs till my hair had grown back because I was far too embarrassed to walk around with short hair. Despite my lack of finances at the time, one of the upsides to living in the transitional-living program was that I was finally able to dress in clothing options I felt represented my feminine spirit despite the violent ridicule that came with walking down the streets in feminine-presenting clothing.

(continued on page 133)

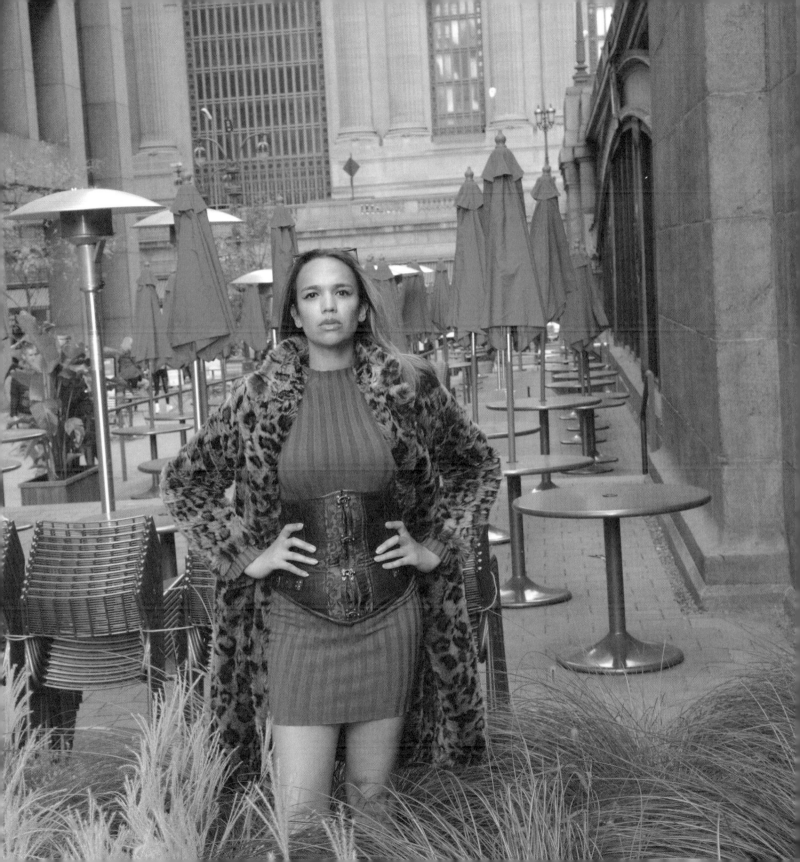

ASHLEY HOU

NAME (FIRST AND/OR LAST): Ashley Hou

HOMETOWN: Hong Kong

CURRENT NEIGHBORHOOD: Midtown East, Manhattan

CURRENT AGE: 38

AGE AT TRANSITION: N/A (gender-fluid)

PREFERRED PRONOUN(S): She, when presenting as female

CAREER/JOB: Finance

RELATIONSHIP STATUS: Single

WHAT WAS YOUR PATH TO TRANSITION LIKE?

I've always struggled with identity. When I was growing up though, I never questioned my gender; after all, I did not know that was even allowed. It wasn't until after college that I realized gender expression was not limited to what you were born as.

WHAT ARE INTERESTING THINGS ABOUT YOU? WHAT MAKES YOU AS A PERSON UNIQUE?

I have an unhealthy amount of knowledge of late eighties/early nineties cartoons and the cosplay to prove it! Very proud of my heritage—born in Hong Kong, mother born in Malaysia, dad [born] in Pakistan, grandparents raised in India, and great-grandparents from China. I'd like to think all those varied backgrounds come together to form one unique person, à la Voltron or Captain Planet (see earlier statement).

WHAT WOULD YOU LIKE PEOPLE TO KNOW ABOUT YOURSELF AS A TRANSGENDER PERSON THAT MIGHT BE VERY DIFFERENT FROM PEOPLE'S IDEAS OF TRANS PEOPLE?

Not every transgender person goes through surgeries or takes hormones. Maybe they will one day, but that's a decision for them to make and no one else.

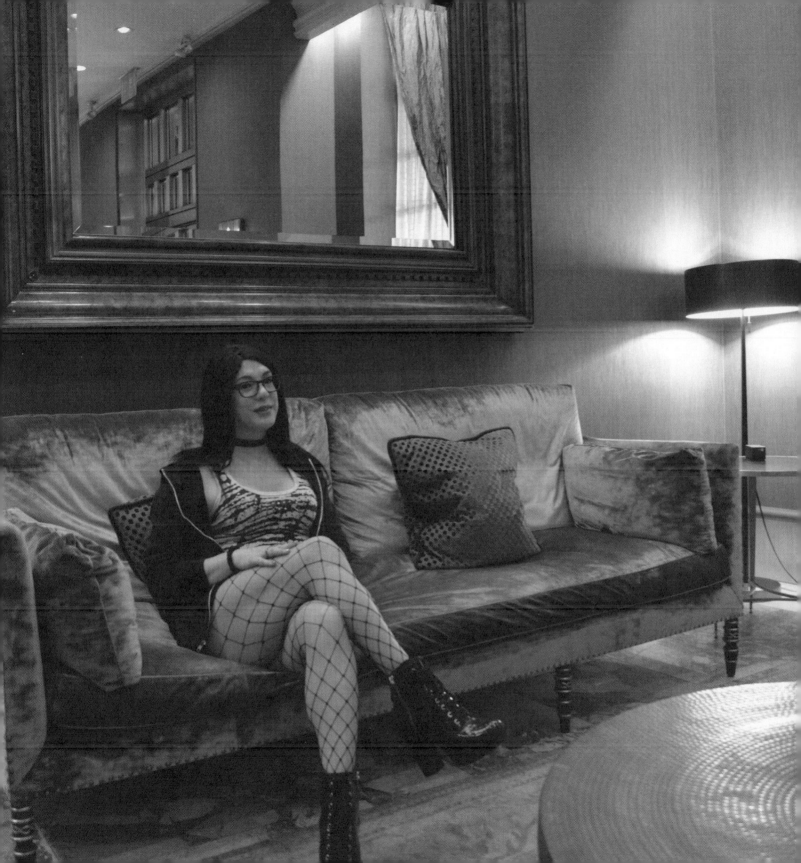

BRYCEN GAINES

NAME (FIRST AND/OR LAST): Brycen Gaines

HOMETOWN: Bronx

CURRENT NEIGHBORHOOD: Bronx

CURRENT AGE: 30

AGE AT TRANSITION: 24

PREFERRED PRONOUN(S): He/him

CAREER/JOB: Rap and visual artist

RELATIONSHIP STATUS: Single

WHAT WAS YOUR PATH TO TRANSITION LIKE?

My path was a little confusing at first as I was confused about who I was and what I wanted to be, but finally it dawned on me that I am a man and what I wanted was to medically transition, so I did.

WHAT ARE INTERESTING THINGS ABOUT YOU? WHAT MAKES YOU AS A PERSON UNIQUE?

I am a rapper and a visual artist and I base my art off of my many experiences as a trans person.

WHAT WOULD YOU LIKE PEOPLE TO KNOW ABOUT YOURSELF AS A TRANSGENDER PERSON THAT MIGHT BE VERY DIFFERENT FROM PEOPLE'S IDEAS OF TRANS PEOPLE?

I'm proud; I am unashamed.

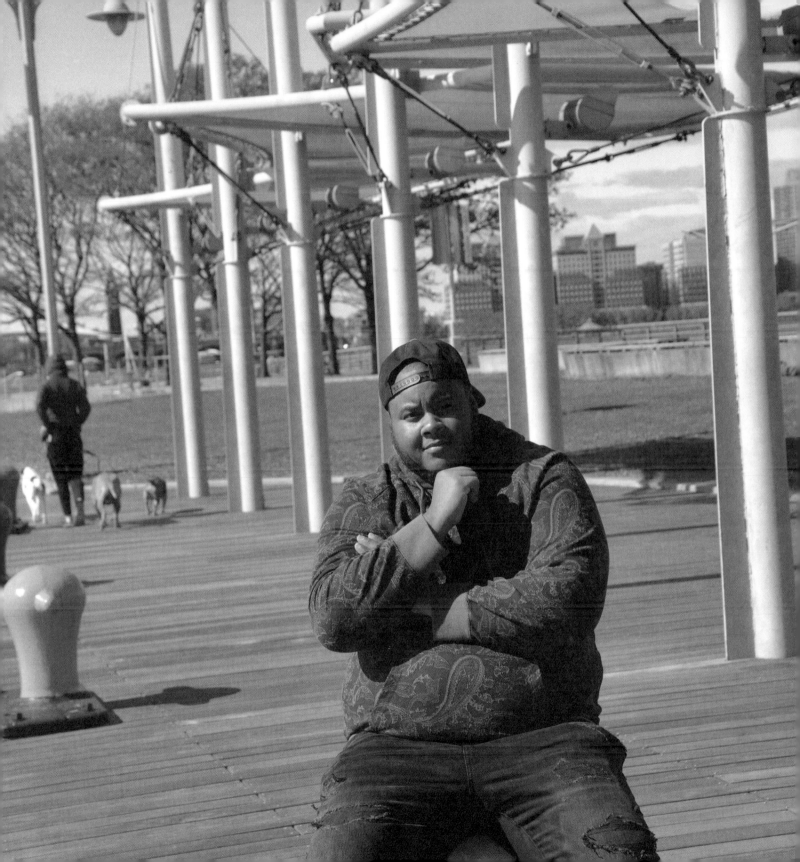

CAMILLA VAZQUEZ

NAME (FIRST AND/OR LAST): Camilla Vazquez

HOMETOWN: Brooklyn

CURRENT NEIGHBORHOOD: Midwood, Brooklyn

CURRENT AGE: 22

AGE AT TRANSITION: 21

PREFERRED PRONOUN(S): She/her

CAREER/JOB: Dog walker/independent model

RELATIONSHIP STATUS: Single

WHAT WAS YOUR PATH TO TRANSITION LIKE?

My path to transition was never clear for me. There was also this lingering voice or shadow negating all of the thoughts that could've led me to transition earlier in life. I had to experience the world in my biological state to maybe learn all that I needed to learn. I always knew my whole entire life I was meant to be a woman but didn't even have the words to describe it to myself. But all I can say is that my path toward finishing my transition is mostly great feelings, a positive mindset, and a well-thought-out plan.

WHAT ARE INTERESTING THINGS ABOUT YOU? WHAT MAKES YOU AS A PERSON UNIQUE?

I was born in Puerto Rico to two teenage parents but raised in Brooklyn. I've always been into performance whether it be singing, dancing, or acting. I later got into modeling once I began transitioning. My beauty to me shines most as a woman, which is my truest form. I want to take my modeling and intertwine it alongside my journey as a hair stylist/wig maker.

WHAT WOULD YOU LIKE PEOPLE TO KNOW ABOUT YOURSELF AS A TRANSGENDER PERSON THAT MIGHT BE VERY DIFFERENT FROM PEOPLE'S IDEAS OF TRANS PEOPLE?

I'm a living, breathing human who has a right to live *my* truth in this world just like everyone else. As cliché as that sounds, I do truly believe people don't know us for who we truly are—hence they disconnect [us] from the rest of the world. Whether we're oversexualized, fetishized, or severely mistreated by the outside world, we continue to just get one point across and that's that we're still *human* beings and should be treated like it. We bleed, hurt, and feel just as much as the next person. The last thing I would also have to put out there is that we *are* what we say we *are*. We would not go down this path of life to purposely endure all that comes with being trans.

Opposite: Jade Huynh (left) and Camilla Vazquez (right)

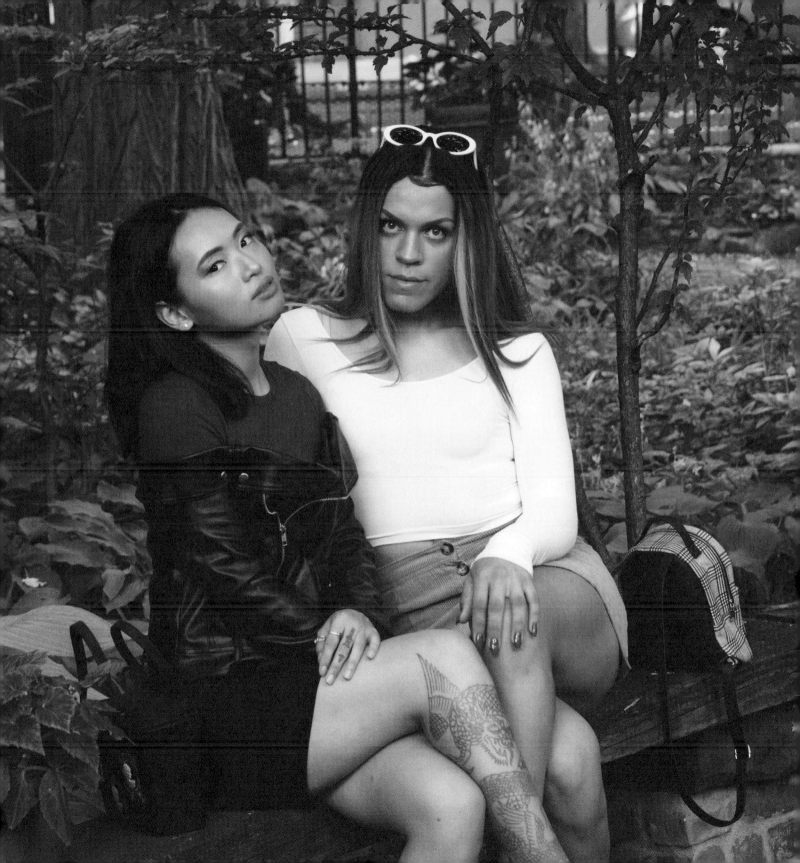

CEYENNE DOROSHOW

NAME (FIRST AND/OR LAST): Ceyenne Doroshow

HOMETOWN: Bushwick, Brooklyn, and Park Slope, Brooklyn

CURRENT NEIGHBORHOOD: Richmond Hill, Queens

CURRENT AGE: 50+

AGE AT TRANSITION: Decades

PREFERRED PRONOUN(S): Lady

CAREER/JOB: Founder of G.L.I.T.S. Inc.

RELATIONSHIP STATUS: N.I. [not interested]

WHAT WAS YOUR PATH TO TRANSITION LIKE?
Hard.

WHAT ARE INTERESTING THINGS ABOUT YOU?
WHAT MAKES YOU AS A PERSON UNIQUE?
Amazing life with many twists.

WHAT WOULD YOU LIKE PEOPLE TO KNOW ABOUT YOURSELF AS A TRANSGENDER PERSON THAT MIGHT BE VERY DIFFERENT FROM PEOPLE'S IDEAS OF TRANS PEOPLE?
My life and work are global and needed. Positive trans role models spread safety and tolerance.

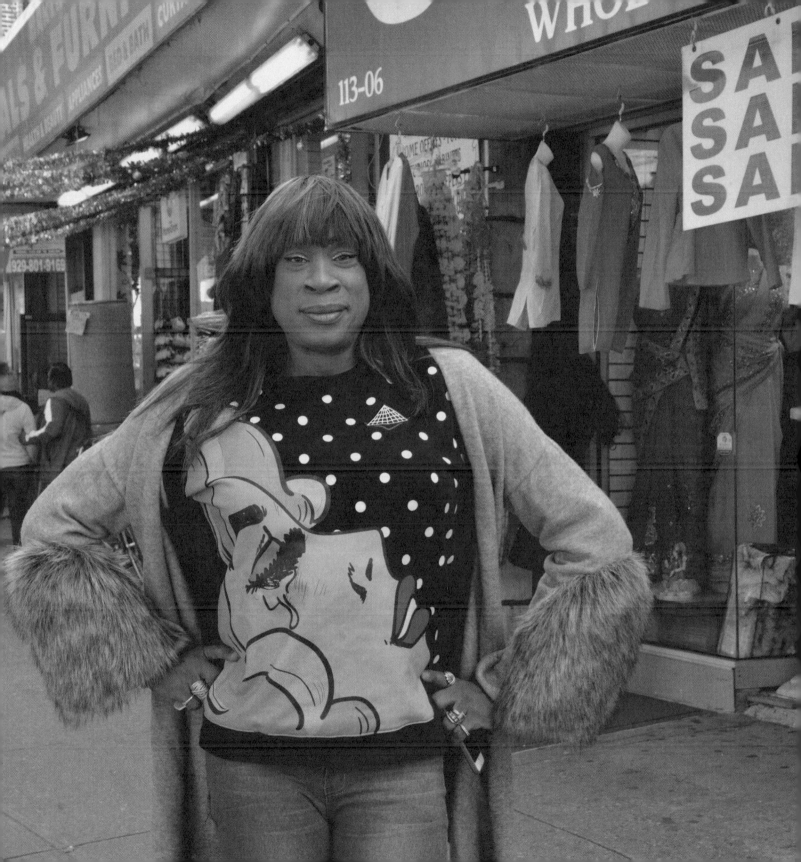

CHETTINO D'ANGELO

NAME (FIRST AND/OR LAST): Chettino D'Angelo

HOMETOWN: Carroll Gardens, Brooklyn

CURRENT NEIGHBORHOOD: Carroll Gardens, Brooklyn

CURRENT AGE: 21

AGE AT TRANSITION: 20

PREFERRED PRONOUN(S): He/him/his

CAREER/JOB: Actor, singer/songwriter

RELATIONSHIP STATUS: Single

WHAT WAS YOUR PATH TO TRANSITION LIKE?

My path to transition had many ups and downs. For most of my life I was someone who believed that I did not matter and that it was more important to put other people's needs before mine. I struggled with loving myself. But when I started recognizing the importance of "filling up my own cup before pouring into others'," that's when I started understanding more about myself. I began internally questioning, "If no one else existed in the world, who would I be and what would I do?" I realized all of the reasons that I was continuing to live life as a woman were for other people and not for me. I did so much unraveling of my feelings, gradually stepping more and more into the person I'm destined to be. For quite some time I was learning more about self-love and practicing it. Admitting that I was a man and deciding to go through the physical process of transitioning is when I was truly feeling the love that I have inside of me. It has helped me learn how to love others from a place of authenticity and abundance. As the days go by, I get further into my transition. It feels like my head and heart are finally agreeing with each other after years of constant battling.

WHAT ARE INTERESTING THINGS ABOUT YOU? WHAT MAKES YOU AS A PERSON UNIQUE?

I love to write songs. Writing love songs is how I show myself love. In the past, I wrote love songs to express my love to others. Now, I write them for myself to myself. I genuinely love all people and I always forgive. We're all guilty of doing wrong at one point or another in our lives. I believe everyone deserves forgiveness and love. I also love helping others experience breakthroughs in their lives. Understanding more about oneself is so important. I believe the more we figure out about ourselves, the closer we are to figuring out what our life's purpose is.

(continued on page 135)

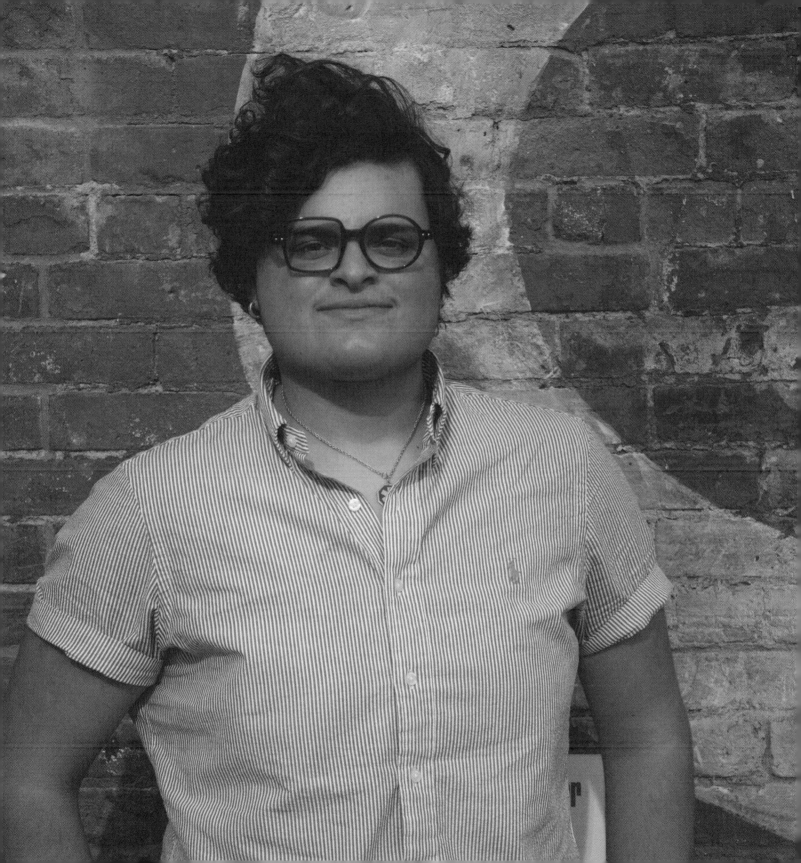

DANIELLE RYE

NAME (FIRST AND/OR LAST): Danielle Rye

HOMETOWN: Fort Myers, Florida

CURRENT NEIGHBORHOOD: New Hyde Park, Nassau County, Long Island

CURRENT AGE: 25

AGE AT TRANSITION: 15

PREFERRED PRONOUN(S): She/her

CAREER/JOB: Model, actress, community organizer

RELATIONSHIP STATUS: Dating Ondreya Dier

WHAT WAS YOUR PATH TO TRANSITION LIKE?

My transition started with a bang. I was fifteen, in South Florida, and began to socially transition very young. I wasn't taking the misgendering anymore, and began to openly defy all the rules around me, ignoring teachers and sneaking off to ballet rehearsal.

WHAT ARE INTERESTING THINGS ABOUT YOU? WHAT MAKES YOU AS A PERSON UNIQUE?

I'm a classically trained ballerina, but I always had a freaky side to me. I wasn't afraid to mess up or look silly. I first learned that being LGBTQ wasn't accepted in the fifth grade when I was shamed for my lisp. I rebelled by reading school passages out loud, in a British accent, à la Harry Potter. That was my way of avoiding conformity.

WHAT WOULD YOU LIKE PEOPLE TO KNOW ABOUT YOURSELF AS A TRANSGENDER PERSON THAT MIGHT BE VERY DIFFERENT FROM PEOPLE'S IDEAS OF TRANS PEOPLE?

The biggest mistake, I've learned, is believing that I had all the answers. I knew how a woman dressed; I knew how a man dressed. Continuing my transition, I quickly learned that these staid expectations would have to go.

The biggest regret I have is having regrets. Live for your future, for yourself.

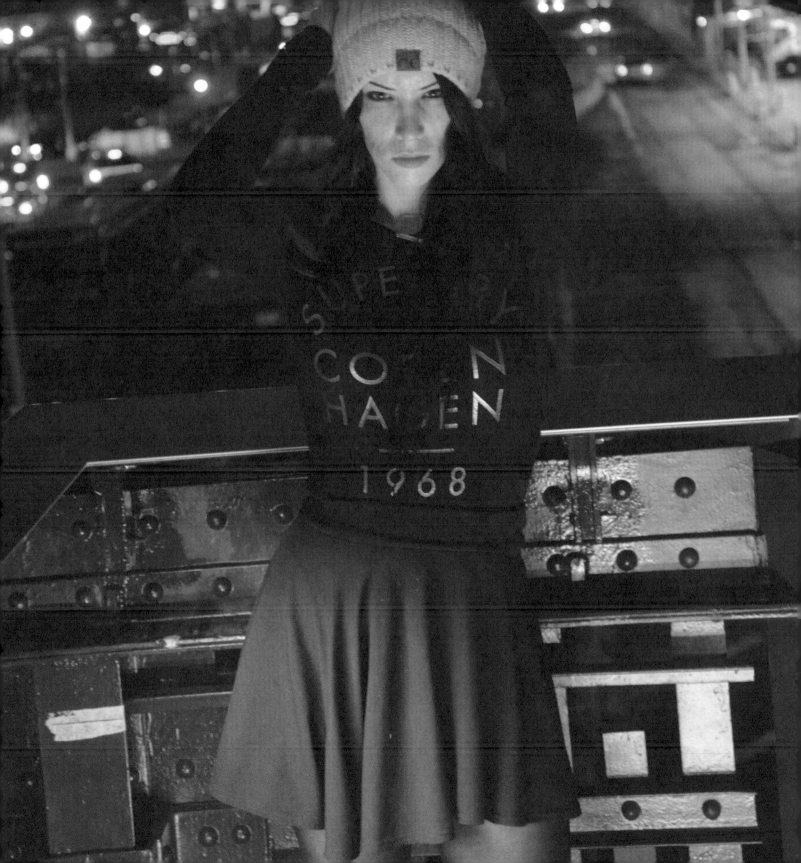

JADE HUYNH

NAME (FIRST AND/OR LAST): Jade Huynh

HOMETOWN: Brooklyn

CURRENT NEIGHBORHOOD: Bensonhurst, Brooklyn

CURRENT AGE: 19

AGE AT TRANSITION: 19

PREFERRED PRONOUN(S): She/her or they/them

CAREER/JOB: Student

RELATIONSHIP STATUS: Single

WHAT WAS YOUR PATH TO TRANSITION LIKE?

Many transgender people say they knew they were transgender at an early age in life, but I didn't really know until I was eighteen. Coming out to my friends and family was not as hard as I thought, but I still get plenty of backlash from people close to me.

WHAT ARE INTERESTING THINGS ABOUT YOU? WHAT MAKES YOU AS A PERSON UNIQUE?

I really can't think of a single thing that sets me apart from other people. I truly believe that we are essentially souls in a physical body experiencing the journey called life. Although we all have our own separate paths, everyone is connected on a deeper, higher level.

WHAT WOULD YOU LIKE PEOPLE TO KNOW ABOUT YOURSELF AS A TRANSGENDER PERSON THAT MIGHT BE VERY DIFFERENT FROM PEOPLE'S IDEAS OF TRANS PEOPLE?

No matter what you think of trans people or who I am as a person, I will continue to exist. You may call me a man dressing as a woman or any other names of that variety, but that will not keep me from living my life. I am a woman, whether you like it or not.

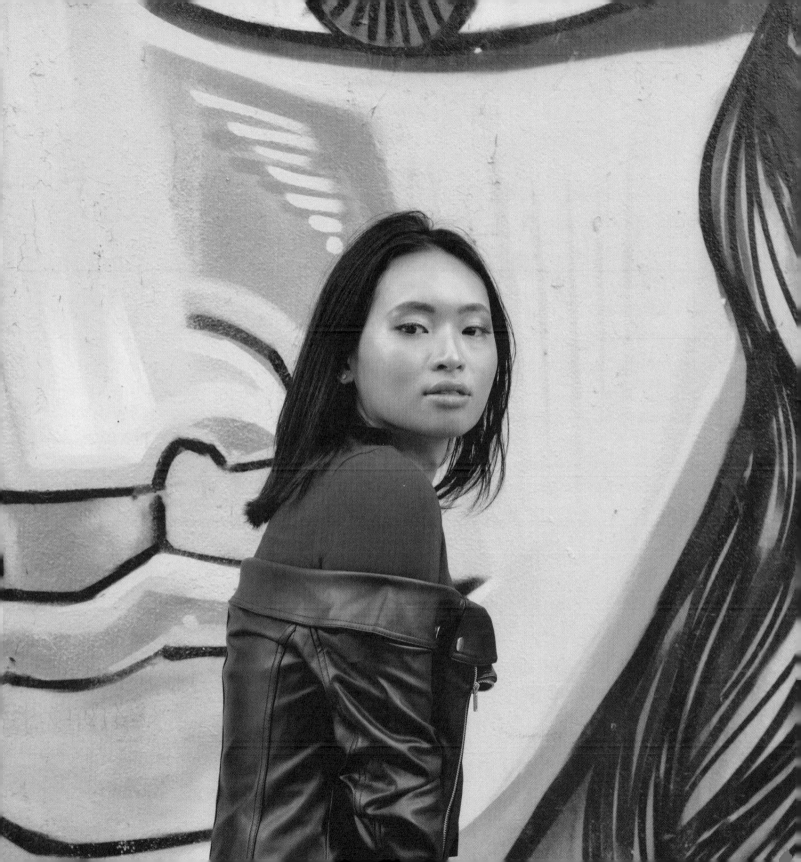

DEREK JAMES

NAME (FIRST AND/OR LAST): Derek James

HOMETOWN: Brooklyn

CURRENT NEIGHBORHOOD: Bushwick, Brooklyn

CURRENT AGE: 35

AGE AT TRANSITION: 33

PREFERRED PRONOUN(S): He/him/his

CAREER/JOB: Disc jockey/movie production/entertainment

RELATIONSHIP STATUS: Happily taken/committed

WHAT WAS YOUR PATH TO TRANSITION LIKE?

It was tough. I didn't know about the option to transition until later in life. I went through various labels prior to realizing I was male. I think doing it this late in life has its advantages, but can't help but wonder if I did it during puberty how different life would be.

WHAT ARE INTERESTING THINGS ABOUT YOU? WHAT MAKES YOU AS A PERSON UNIQUE?

I am someone who thrives on love and good vibes. I've been through a lot of bad things in my life up until this point and I've come to learn that we're all the same and everyone deserves love and understanding at the bare minimum. Materialistic things don't impress me, but if you're kind to others, that makes an impact.

WHAT WOULD YOU LIKE PEOPLE TO KNOW ABOUT YOURSELF AS A TRANSGENDER PERSON THAT MIGHT BE VERY DIFFERENT FROM PEOPLE'S IDEAS OF TRANS PEOPLE?

I feel people think trans people "want to be" men or women without realizing [being trans] isn't [a] choice. If I had one, I'd be in the right body at birth; unfortunately, it didn't happen that way. I'm doing my best given the cards I was dealt, which should be universally respected. Being trans isn't easy for any of us and some have it harder than others. No one chooses to be on meds forever to feel comfortable in their skin and I truly wish it wasn't a necessity; however, it's something I must do to enjoy the rest of my life.

Opposite: Miranda Miranda (left) and Derek James (right)

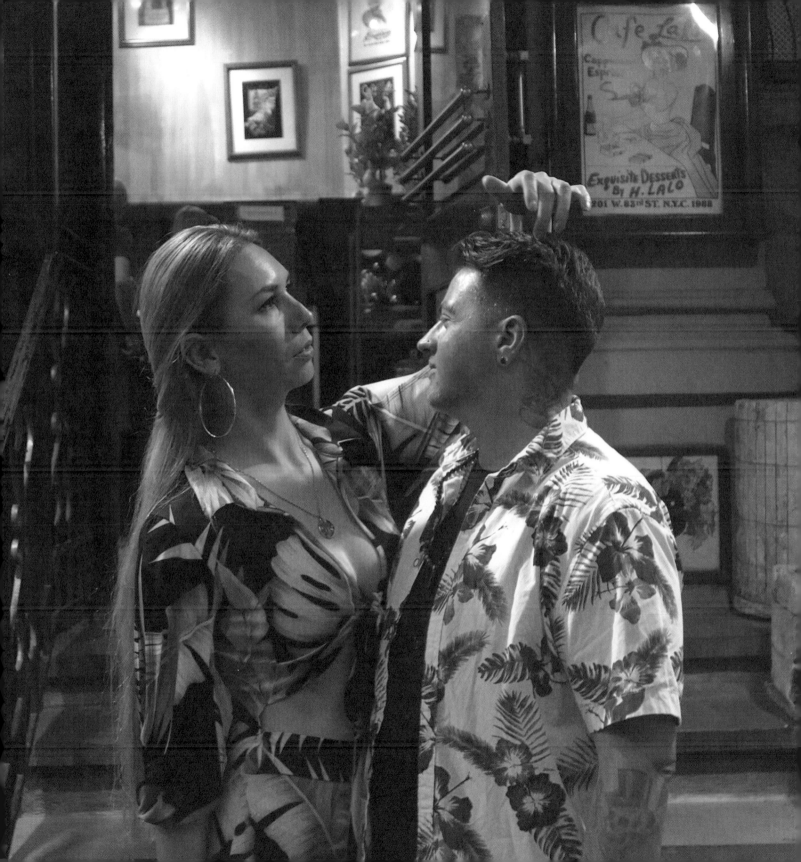

DRAE

NAME (FIRST AND/OR LAST): Drae

HOMETOWN: The Bay Area, California

CURRENT NEIGHBORHOOD: Brooklyn

CURRENT AGE: 40s

AGE AT TRANSITION: I basically became "more butch" and masculine in my early- to mid-thirties. I went from tomboy to femme to futch to dandy to butch and I basically have variations on those last two. I'm a dandy-butch-boi-masculine. Among other things. . . .

PREFERRED PRONOUN(S): She/her

CAREER/JOB: Actor/dog walker/storyteller

RELATIONSHIP STATUS: Single-ish, dating.

WHAT WAS YOUR PATH TO TRANSITION LIKE?

I don't identify as trans, per se. I don't want to take up that space necessarily. Although I check a lot of boxes and live a life that is relatively nonbinary, masculine, feminine, whatever. I'm really grateful to trans folks in general. To the queer community at large.

I'm a woman who is "butch," gender nonconforming, genderqueer. That being said, my gender is always evolving. I often get called sir or ma'am and it doesn't bother me at all. Unless someone is threatening. . . . I wrote a one-person show that tells the story of my gender presentation and identity through my many actor's headshots through the years. Starting at eighteen when I had long blonde curly hair up to now with my short, close-cropped, salt-and-pepper cut.

WHAT ARE INTERESTING THINGS ABOUT YOU? WHAT MAKES YOU AS A PERSON UNIQUE?

I can speak backward. I'm in a tenant association where I live and we won a big settlement against our landlords! I know a lot of my neighbors. I love my dog. I'm the youngest of nine children. Although my family is brilliant and artistic, I was the first one in our family to go to college. I'm one of three queer siblings in my family. I have a queer storytelling podcast and a live show called *TELL*. It features queer stories from queer folks. I believe our stories strengthen us and keep us safe. :)

WHAT WOULD YOU LIKE PEOPLE TO KNOW ABOUT YOURSELF AS A TRANSGENDER PERSON THAT MIGHT BE VERY DIFFERENT FROM PEOPLE'S IDEAS OF TRANS PEOPLE?

It's not always easy, but I love myself and I have loving, supportive friends and family. Not everyone has that, but there are those of us that do.

E LEIFER

NAME (FIRST AND/OR LAST): E Leifer

HOMETOWN: New York

CURRENT NEIGHBORHOOD: Hell's Kitchen, Manhattan

CURRENT AGE: 49

AGE AT TRANSITION: 45

PREFERRED PRONOUN(S): He/she/they

CAREER/JOB: Co-owner of Play Out Apparel

RELATIONSHIP STATUS: Married

WHAT WAS YOUR PATH TO TRANSITION LIKE?

I didn't come to understand my gender identity until late in the game, having always associated it with my sexual identity, which I now recognize is totally separate. For thirty years I identified as a lesbian and then a very "butch" lesbian. Although I was masculine presenting for many years, it wasn't until I was in my forties and I had a preventative double mastectomy with no reconstruction that a light went on in my head. The whole picture came into view with inescapable clarity. All those years, I had never applied the terminology, the hard questions I understood for others in my life, toward myself and my own identity. It was then that I knew I was trans-masculine/nonbinary and from that moment on I gave myself full permission to explore and engage with what that meant for me. The sense of freedom and possibility I gained was, and still is, astounding.

WHAT ARE INTERESTING THINGS ABOUT YOU? WHAT MAKES YOU AS A PERSON UNIQUE?

I started as a painter, moved into film and TV production and styling, then fashion photography, leading me to my current career as a creative director and designer, co-owning a gender-equal apparel company.

I'm a true "big picture" thinker and hard-core problem solver.

I've traveled the world and had a tremendous array of experiences that allow me to be clever and very empathetic.

I have lived a life that has been quite extreme and been able to navigate through it to become a very kind, nurturing person who has extraordinary insight into the human condition and its varied behaviors.

(continued on page 136)

ERIKA BARKER

NAME (FIRST AND/OR LAST): Erika Barker

HOMETOWN: Summerfield, Florida

CURRENT NEIGHBORHOOD: Tribeca, Manhattan

CURRENT AGE: 37

AGE AT TRANSITION: 27

PREFERRED PRONOUN(S): Her

CAREER/JOB: Photographer/content creator

RELATIONSHIP STATUS: Single

WHAT WAS YOUR PATH TO TRANSITION LIKE?

My path to transition started with me being a child in the eighties and knowing something was not right around the age of four. It's difficult for me to describe the pressure, and what went on in my brain as a child. For me to attempt describing this is like trying to describe a shade of color to a person who suffers from color blindness. All I can tell you is that it caused a lot of mental suffering and constantly questioning myself growing up.

I recall watching *Sally Jessy Raphael*, a talk show in the early nineties, and I saw for the first time these beautiful women who were formerly men.

They were post-op and looked amazing. For the first time in my life I realized I was not alone. I wanted to be them. However, I was incredibly conflicted because I grew up in a religious household. My father was Baptist, and I respected him a lot. I was quite religious myself when I was growing up, and I even wanted to be a preacher at one point. In my early twenties, however, with constant thoughts of suicide, depression, and mixed feelings between faith and the struggle going on in my head, I decided to join the military to force myself to live in a world where I could learn to be a stronger man. I joined the Navy and became a combat photographer. At the age of twenty-four, however, coming back from Afghanistan, I was a little less religious and decided that life is short and I wanted to transition. I was discharged in 2009 at the age of twenty-six and started transitioning right away. I grew my hair out, took hormones, and I recall that telling my parents and my friends was tougher than anything I ever did in the military. At this time, I decided to go back to school, but I did not want to transition from Erik to Erika with my cohorts. I decided to speed things up; I would get hair extensions on a Friday, and thus, just like jumping into the deep end of the pool to learn

(continued on page 136)

GIAURA FERRIS

NAME (FIRST AND/OR LAST): Giaura Ferris

HOMETOWN: Philadelphia, Pennsylvania

CURRENT NEIGHBORHOOD: Bushwick, Brooklyn

CURRENT AGE: 30

AGE AT TRANSITION: 22

PREFERRED PRONOUN(S): She/hers/her

CAREER/JOB:

RELATIONSHIP STATUS: Single

WHAT WAS YOUR PATH TO TRANSITION LIKE?

My path to transition came from a feeling of my rebellious nature and questioning of societal norms. I always enjoyed the abilities of a chameleon. Having the ability to infiltrate any group or crowd. I enjoy being what I feel [like being on] any given day. Provoking reactions in others with my freedom of expression. I feel like I own the ripples I make in the water when something sinks in.

WHAT ARE INTERESTING THINGS ABOUT YOU? WHAT MAKES YOU AS A PERSON UNIQUE?

I am a witch, healer, and muse. I have a divination, energy movement, and healing business. I offer services such as tarot readings and spell castings to move energy in my clients' lives. I integrate my knowledge of the occult into creative collaboration for businesses and brands.

WHAT WOULD YOU LIKE PEOPLE TO KNOW ABOUT YOURSELF AS A TRANSGENDER PERSON THAT MIGHT BE VERY DIFFERENT FROM PEOPLE'S IDEAS OF TRANS PEOPLE?

As a transgender person, I would like people to know I am an individual first. The way I experience and express my gender, womxnhood, and femininity is by my own design. My trans-ness is not validated by physiological changes nor by passing among cisgender normative society. My experience as a womxn has been one of mind, heart, spirit, and soul. As a transgender individual, I claim and own my satisfaction in embracing my multidimensionality.

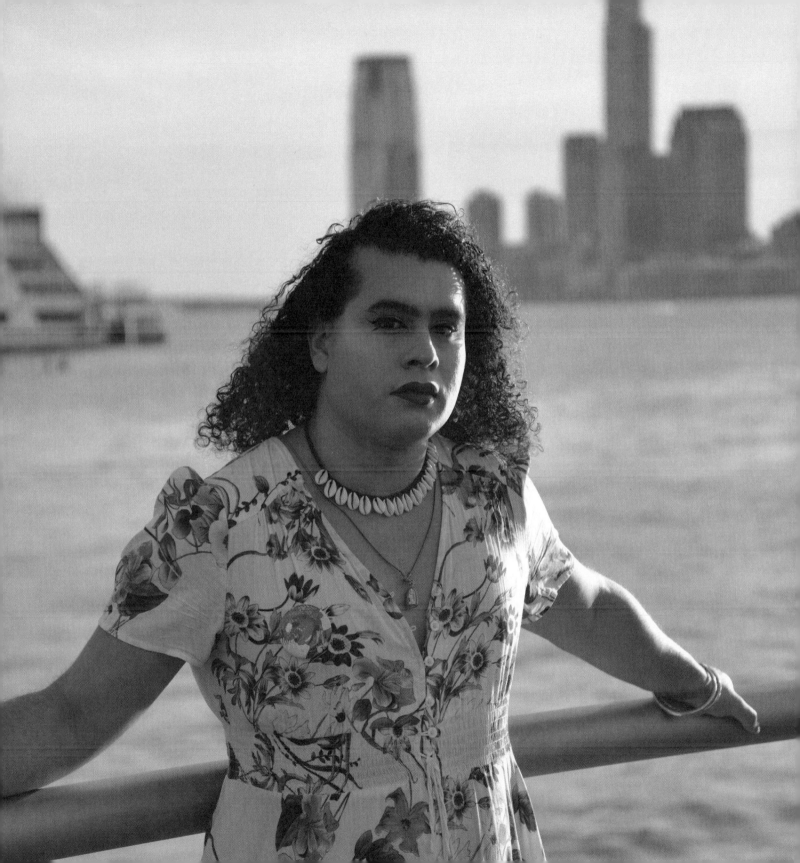

GRACE DETREVARAH

NAME (FIRST AND/OR LAST): Grace Detrevarah

HOMETOWN: Detroit, Michigan

CURRENT NEIGHBORHOOD: Brooklyn

CURRENT AGE: 56

AGE AT TRANSITION: 40

PREFERRED PRONOUN(S): She, miss, her

CAREER/JOB: Health and reentry advocate/ case manager

RELATIONSHIP STATUS: Dating

WHAT WAS YOUR PATH TO TRANSITION LIKE?

Personally—great, relieving. Physically—complicated.

WHAT ARE INTERESTING THINGS ABOUT YOU?
WHAT MAKES YOU AS A PERSON UNIQUE?

Spiritual, isolator, and friendly.

WHAT WOULD YOU LIKE PEOPLE TO KNOW ABOUT YOURSELF AS A TRANSGENDER PERSON THAT MIGHT BE VERY DIFFERENT FROM PEOPLE'S IDEAS OF TRANS PEOPLE?

That the life of "me" is no different from others . . . in the human condition.

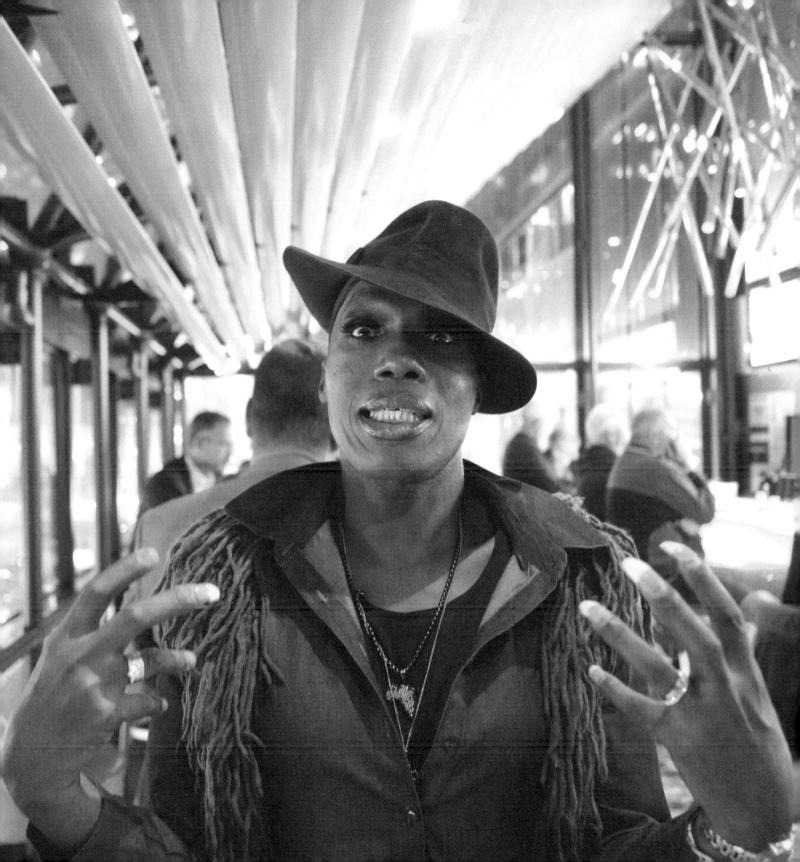

HEATHER LELA GRAHAM,
A.K.A LEE GRAHAM, A.K.A LEE VALONE

NAME (FIRST AND/OR LAST): Heather Lela Graham, a.k.a. Lee Graham, a.k.a. Lee Valone

HOMETOWN: Asheville, North Carolina, born and raised. I lived in the Appalachian Mountains of western North Carolina my whole life before I moved to Brooklyn in 2011.

CURRENT NEIGHBORHOOD: Flatbush, Brooklyn

CURRENT AGE: 32

AGE AT TRANSITION: Hmm. I don't know how to answer that question as I've always been trans. I "came out" as a person who isn't a woman at twenty-eight, I think? I started HRT therapy November 2018.

PREFERRED PRONOUN(S): He/him

CAREER/JOB: I, like most thirty-two-year-olds in New York City, work four jobs. If I had to umbrella these jobs as a career, I would say I am a professional caretaker. I am trained as a preschool teacher. I worked as a full-time caregiver throughout my time in university and my first few years as an adult. I now work as a private nanny, a studio assistant, and various other odd jobs.

RELATIONSHIP STATUS: I am married to my amazing partner, Evan (also thirty-two, also from Asheville). We have been together since we were nineteen.

WHAT WAS YOUR PATH TO TRANSITION LIKE?

For me, my path to transition was a series of small realizations, never a big "aha" moment. I had never even heard the word "transgender" until I was a sophomore in college.

WHAT ARE INTERESTING THINGS ABOUT YOU?
WHAT MAKES YOU AS A PERSON UNIQUE?

I think my most unique trait is my ability to adapt. I come from a very standard-issue Southern family problem—father was a Vietnam War vet with untreated PTSD and a drinking problem who beat my mother and my sister. I learned very quickly how to hide, stay hidden, and not get hurt. I learned in school if I got average grades, I wouldn't stand out. I learned that if I gained weight, men and boys would leave me alone. I learned that if I worked my ass off I could get what I wanted. I was one of the only people I knew in school who was exclusively paying for their education themselves so I took school extremely seriously. I learned that if I could change and adapt, I could do anything. I moved to NYC with less than two months' rent saved, no job, and no prospects. I think my adaptability has kept me alive.

(continued on page 137)

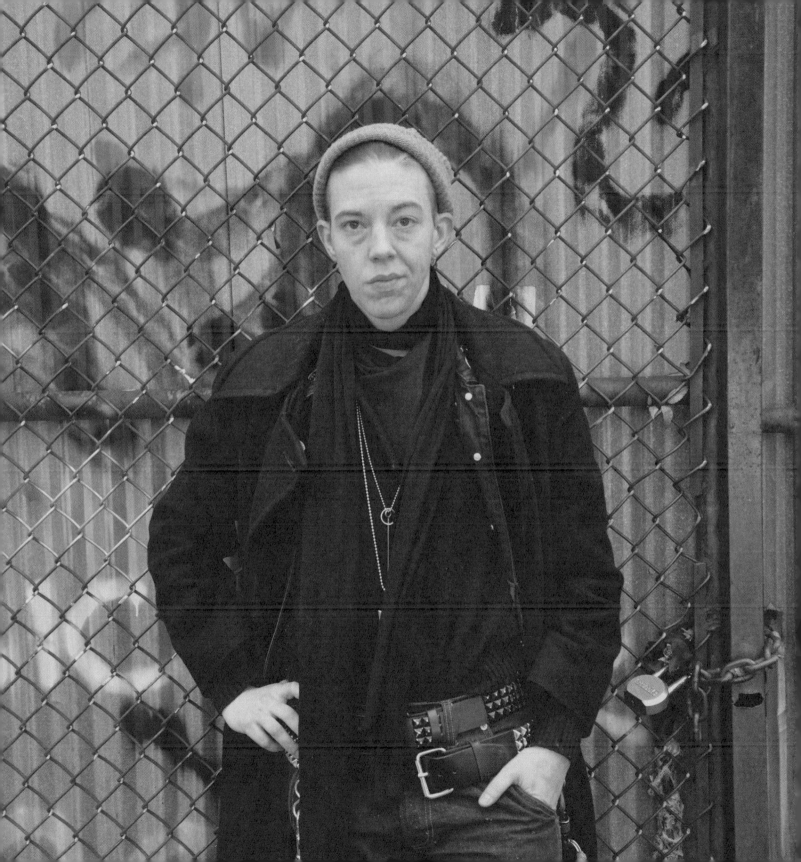

ISAAC GRIVITT

NAME (FIRST AND/OR LAST): Isaac Grivitt

HOMETOWN: Laguna Niguel, California

CURRENT NEIGHBORHOOD: Hell's Kitchen, Manhattan

CURRENT AGE: 22

AGE AT TRANSITION: 17

PREFERRED PRONOUN(S): He/they

CAREER/JOB: Theater costumer

RELATIONSHIP STATUS: Single

WHAT WAS YOUR PATH TO TRANSITION LIKE?

I was the first person, and first student athlete, at my school to publicly come out. I started HRT and came out via Facebook right before my senior year. I was sort of forced into being my own advocate and teaching school staff about trans people and laws surrounding us, and I've carried that into my advocacy work today.

WHAT ARE INTERESTING THINGS ABOUT YOU? WHAT MAKES YOU AS A PERSON UNIQUE?

I did not go to college but instead went to a theater technician training program designed to help diversify the profession. I like to use my passions for running and theater to advocate for disabled trans, gay, and HIV+ people.

WHAT WOULD YOU LIKE PEOPLE TO KNOW ABOUT YOURSELF AS A TRANSGENDER PERSON THAT MIGHT BE VERY DIFFERENT FROM PEOPLE'S IDEAS OF TRANS PEOPLE?

I'm definitely not the idea of a trans man—overly masculine and maybe sort of compensating for being a girl. [I'm] gay, I sew for a living, I wear mainly "women's clothing." My being a man has nothing to do with male gender roles and I have every right to be, and act as, myself, as cisgender men do.

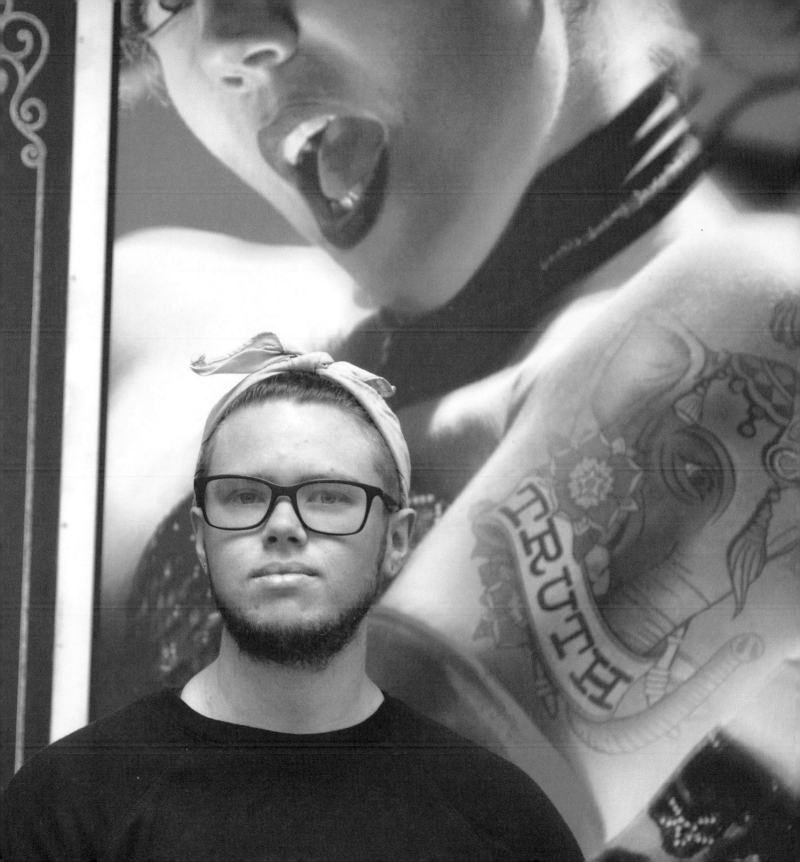

ISABEL RITA

NAME (FIRST AND/OR LAST): Isabel Rita

HOMETOWN: New York

CURRENT NEIGHBORHOOD: Upper Manhattan

CURRENT AGE: 59

AGE AT TRANSITION: 41 (first time), 42 (reverse transition), and 52

PREFERRED PRONOUN(S): She

CAREER/JOB: Engineering, psychology, photography, computer science, design, generative arts, creative direction

RELATIONSHIP STATUS: Single

WHAT WAS YOUR PATH TO TRANSITION LIKE?

It was a very long process, both mentally and physically.

Often fascinating, sometimes terrifying, especially the big day when you "officially" switch genders in front of the whole world (that's the feeling anyway).

WHAT ARE INTERESTING THINGS ABOUT YOU? WHAT MAKES YOU AS A PERSON UNIQUE?

Being a trans woman has given me a unique set of personal skills.

I never thought this unique experience of life would be so emotionally and intellectually rich in so many ways.

WHAT WOULD YOU LIKE PEOPLE TO KNOW ABOUT YOURSELF AS A TRANSGENDER PERSON THAT MIGHT BE VERY DIFFERENT FROM PEOPLE'S IDEAS OF TRANS PEOPLE?

I'm a creative visual design professional that works with top executives for the biggest companies in the world, making very large presentations using the latest technologies.

My passion is to always learn new things and new ways to experience life in full.

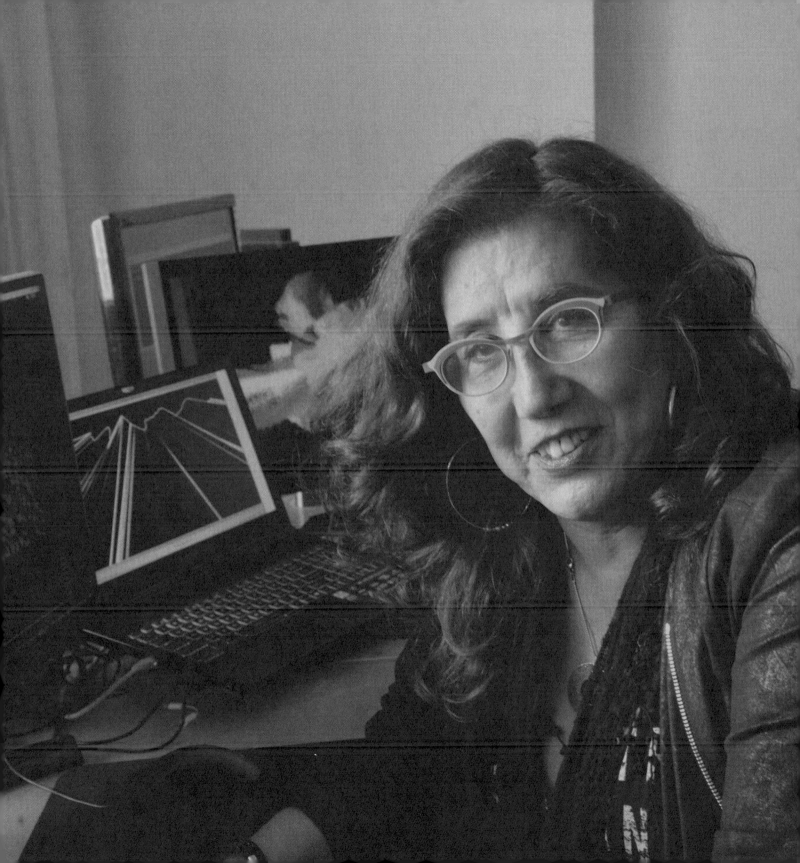

JADA DOWNS

NAME (FIRST AND/OR LAST): Jada Downs

HOMETOWN: Bastrop, Louisiana

CURRENT NEIGHBORHOOD: Bronx

CURRENT AGE: 46

AGE AT TRANSITION: 18

PREFERRED PRONOUN(S): She

CAREER/JOB: Hairstylist

RELATIONSHIP STATUS: Single

WHAT WAS YOUR PATH TO TRANSITION LIKE?

Transition till now has had its ups and downs. I was fortunate enough to be guided by trans women of age who are strong and parental women. Having my sex-change surgery was the best thing ever.

WHAT ARE INTERESTING THINGS ABOUT YOU? WHAT MAKES YOU AS A PERSON UNIQUE?

I am a person that is down to earth and loves helping people, mainly our LGBT youth. This inspired me to attend college for human service.

WHAT WOULD YOU LIKE PEOPLE TO KNOW ABOUT YOURSELF AS A TRANSGENDER PERSON THAT MIGHT BE VERY DIFFERENT FROM PEOPLE'S IDEAS OF TRANS PEOPLE?

Living as a trans woman is not easy mainly because of the stereotype that people put on us. As a trans woman who has survived domestic violence and abuse on many different levels from home to drugs, I use my past experiences as motivation to keep pushing high. Trans women can live normal lives too.

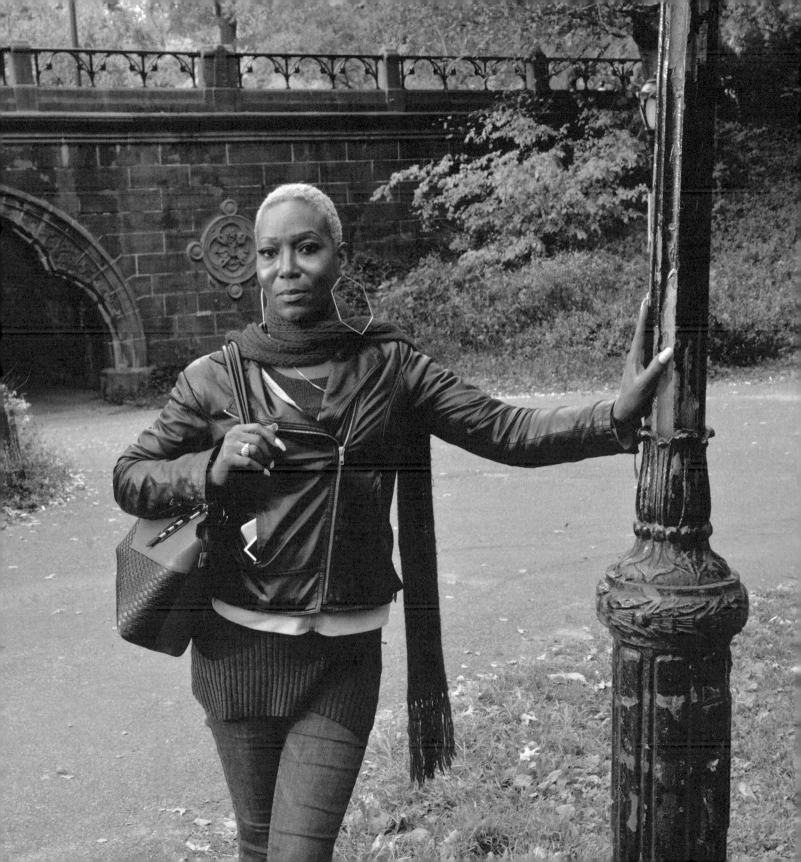

JE'JAE CLEOPATRA DANIELS

NAME (FIRST AND/OR LAST): Je'Jae Cleopatra Daniels

HOMETOWN: Rosh Haayin, Israel

CURRENT NEIGHBORHOOD: Lower East Side, Manhattan

CURRENT AGE: 26

AGE AT TRANSITION: Blooming every year

PREFERRED PRONOUN(S): They/them and Queen

CAREER/JOB: Librarian/artist

RELATIONSHIP STATUS: Free as a bird

WHAT WAS YOUR PATH TO TRANSITION LIKE?

Regardless of the world trying to suppress my divine femininity, I kept pushing back, expressing freely, identifying proudly/clearly, and knowing my worth! I played with pronouns for seven years as well as gender presentation and hormones to find a right fit. The journey is vibes and I'm evolving into a sunflower.

WHAT ARE INTERESTING THINGS ABOUT YOU? WHAT MAKES YOU AS A PERSON UNIQUE?

I'm resilient, a survivor of trauma/abuse, bad a$$ activist, artist, orator. I'm proud to have become a victor of my victimhood, where that neglected child is now revered.

WHAT WOULD YOU LIKE PEOPLE TO KNOW ABOUT YOURSELF AS A TRANSGENDER PERSON THAT MIGHT BE VERY DIFFERENT FROM PEOPLE'S IDEAS OF TRANS PEOPLE?

1) Nonbinary people/gender-variant folks are 250 percent as valid as trans and humans as anyone else. 2) Mind your f*cking business. 3) All spaces should be safe for TGNCI+ [Transgender, Gender Nonconforming, and Intersex+] folks to gain support and experiment what affirming choices to take with their identities. 4) Why be a boy or a girl when you can be both? We make the world interesting!

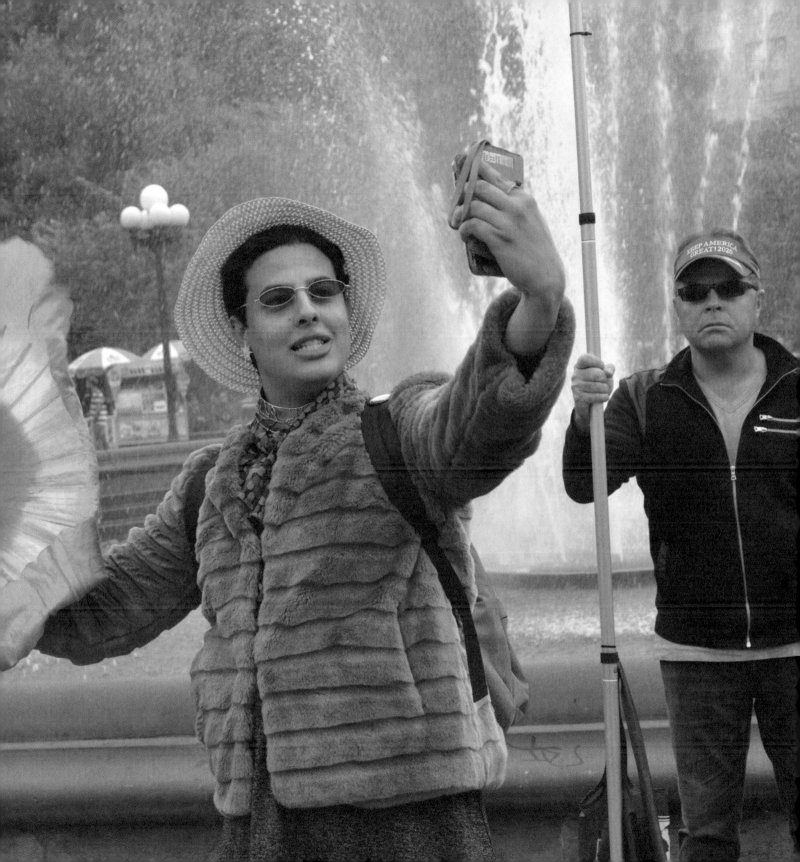

JEVON MARTIN

NAME (FIRST AND/OR LAST): Jevon Martin

HOMETOWN: Harlem, Manhattan

CURRENT NEIGHBORHOOD: Bronx, Manhattan

CURRENT AGE: 49

AGE AT TRANSITION: 28

PREFERRED PRONOUN(S): He/him/his, King

CAREER/JOB: Founder/CEO of Princess Janae Place and MTA conductor

RELATIONSHIP STATUS: Married

WHAT WAS YOUR PATH TO TRANSITION LIKE?

My path to transition was lonely and uninformative. I didn't have any help navigating services; the clinics didn't have trans men knowledge.

WHAT ARE INTERESTING THINGS ABOUT YOU? WHAT MAKES YOU AS A PERSON UNIQUE?

One interesting thing about me is that I am the first Mr. Trans New York USA 2020, newly [appointed] a few weeks ago. I am also one of the trans man elders [of the first trans men's fraternity, Theta Beta Chi, which works to build brotherhood among black trans men in New York City and around the country] and the founder and executive director of Princess Janae Place, which is the only trans-led grassroots nonprofit housing organization in New York.

WHAT WOULD YOU LIKE PEOPLE TO KNOW ABOUT YOURSELF AS A TRANSGENDER PERSON THAT MIGHT BE VERY DIFFERENT FROM PEOPLE'S IDEAS OF TRANS PEOPLE?

What I would like people to know about me as a trans man is that I am human just as they are. I deserve love and respect. I am a parent, brother, husband, and friend.

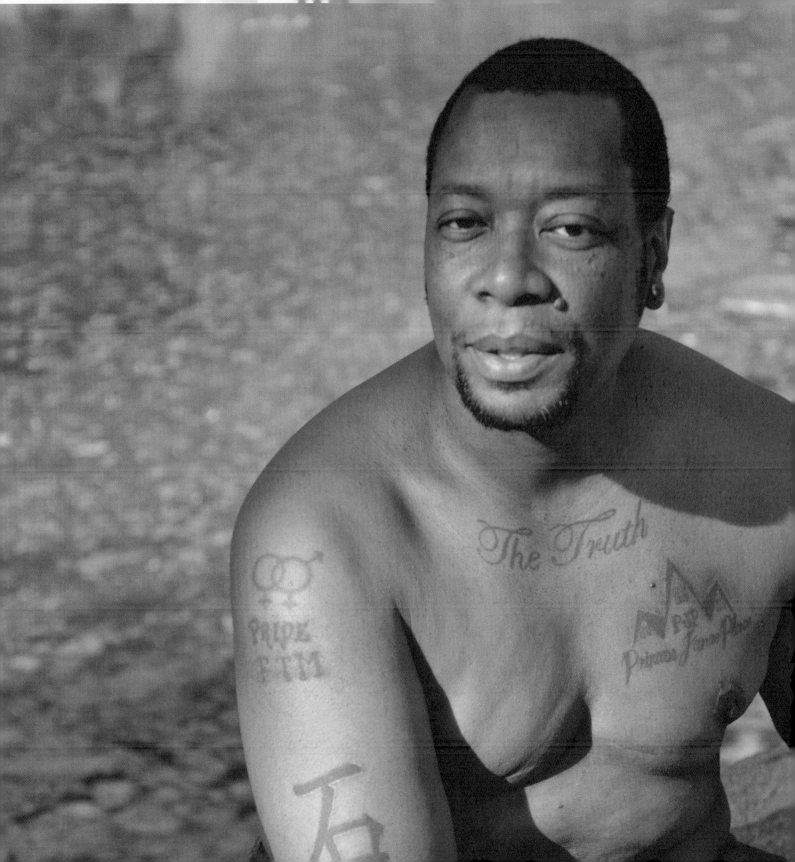

JOANNA FANG

NAME (FIRST AND/OR LAST): Joanna Fang

HOMETOWN: San Marino, California

CURRENT NEIGHBORHOOD: Peekskill, Westchester County

CURRENT AGE: 28

AGE AT TRANSITION: 25

PREFERRED PRONOUN(S): She/her

CAREER/JOB: Foley artist and sound editor

RELATIONSHIP STATUS:

WHAT WAS YOUR PATH TO TRANSITION LIKE?

Besides certain elements of my medical transition, I've always been in a state of transition. I came to understand my gender dysphoria at a very young age. The more I understood gender, the more discomfort and pain I suffered in my assignment at birth. All of those feelings came to a head in the early 2000s. In my teenage years, the *Los Angeles Times* covered the murder of Gwen Araujo and the trans panic defense her murderers used in court. I followed the case closely and unbeknownst to my parents, I would clip out the articles and reread them over and over. Gwen's story was a revelation and a warning: I

was not alone in my pain, but society would not be kind to trans women like us. Being the only male-assigned child in a Taiwanese American family put me under a lot of pressure to live up to the expectations of being the heir to the family name. Puberty was not pleasant for a trans girl trapped in the closet in the mid-2000s. After several attempts at ending my own life, I made a promise to myself. I simply had to survive to independence. I had to survive to the point where my trans-ness was irrelevant, and I had to survive for my future self and survive for women like Gwen before me, and countless young women after.

WHAT ARE INTERESTING THINGS ABOUT YOU? WHAT MAKES YOU AS A PERSON UNIQUE?

I'm really just your average Taiwanese American, Primetime Emmy Award–winning Foley artist, sound designer, singer, poet, trans woman. In 2015, I was recognized by the Television Academy as the first openly transgender woman to win the Primetime Emmy. I had just come out of the closet and three months into my professional transition, I found myself on stage accepting the award with my coworkers by my side. The experience reminded me

(continued on page 138)

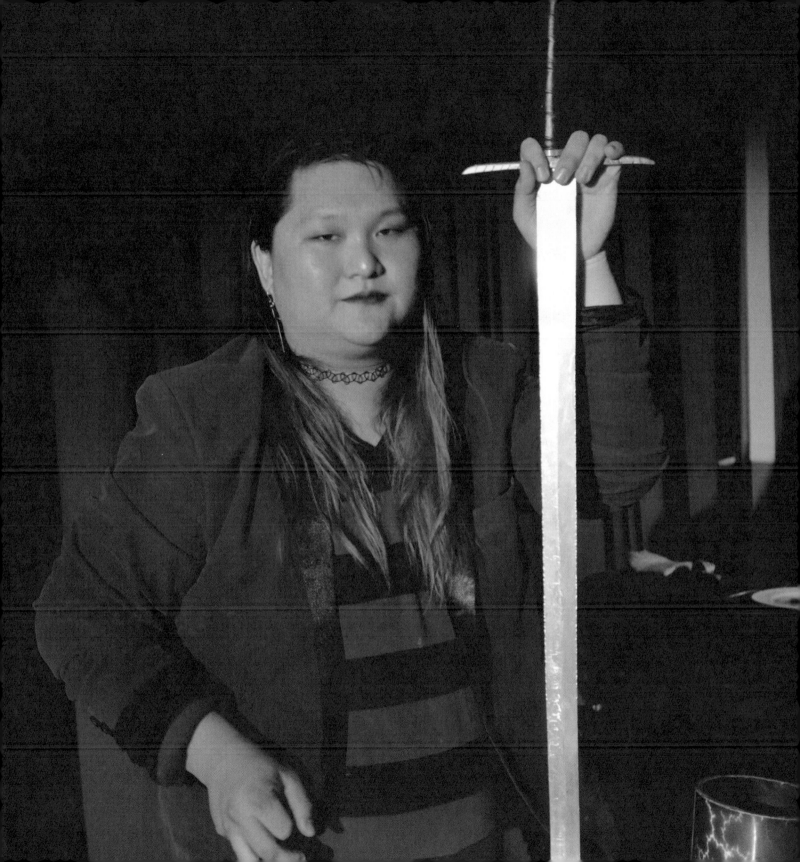

JORDAN RUBENSTEIN

NAME (FIRST AND/OR LAST): Jordan Rubenstein

HOMETOWN: Suburbs of Washington, DC

CURRENT NEIGHBORHOOD: Queens

CURRENT AGE: 31

AGE AT TRANSITION: Life is a continuous state of transition

PREFERRED PRONOUN(S): They/them

CAREER/JOB: Digital marketing

RELATIONSHIP STATUS: Married

WHAT WAS YOUR PATH TO TRANSITION LIKE?

My path to transition was long and drawn out. At first, I was ashamed, having only seen negative representations of trans people, and I went in and out of denial. Over the years, I've grown to accept and love my gender, and to trust and respect myself to make the right decisions about my body and my medical care. Each step I took in my social, legal, and medical transition has made me feel more comfortable with myself.

WHAT ARE INTERESTING THINGS ABOUT YOU? WHAT MAKES YOU AS A PERSON UNIQUE?

I love cats, tattoos, nature, and watching TV. I've struggled with depression and anxiety since I was young but my transition has helped me immensely. I now have the mental energy to enjoy hobbies and learn new things. Recently, I've been learning a lot about data and coding in SQL.

WHAT WOULD YOU LIKE PEOPLE TO KNOW ABOUT YOURSELF AS A TRANSGENDER PERSON THAT MIGHT BE VERY DIFFERENT FROM PEOPLE'S IDEAS OF TRANS PEOPLE?

I identify as nonbinary and transgender. I have no desire to "pass" as cisgender or as a binary gender. I medically transitioned to relieve dysphoria, not to fit into binary gender expectations. My medically transitioned body is a nonbinary body, because it's mine. I also don't seek validation from cisgender people. Finding love with another nonbinary person was an important piece of learning to love myself.

Opposite: Alister Rubenstein (left) and Jordan Rubenstein (right)

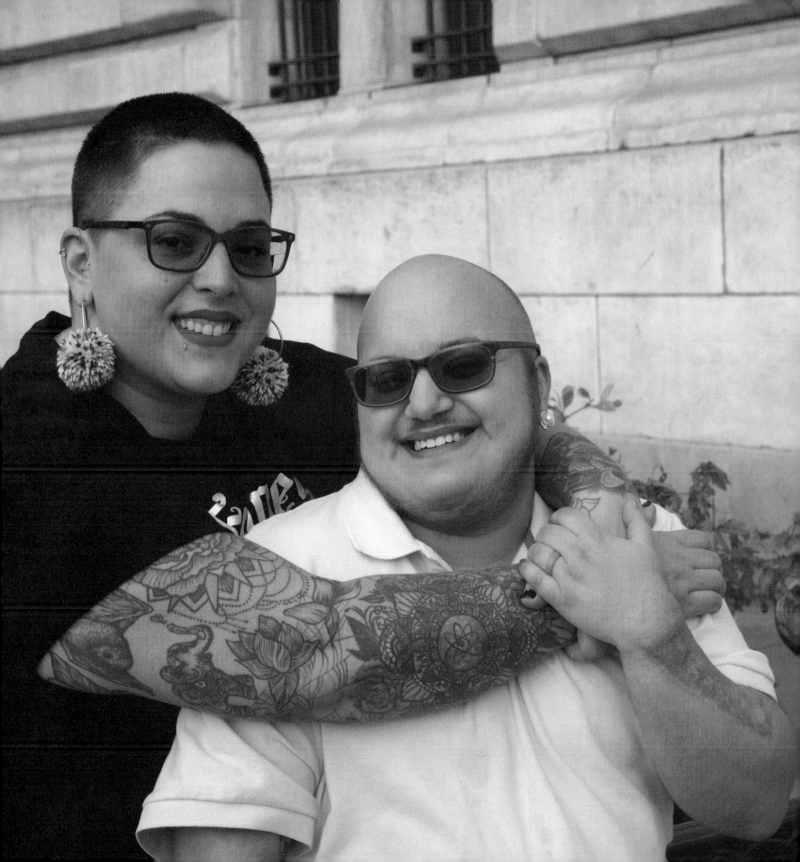

JULIAN OBANDO

NAME (FIRST AND/OR LAST): Julian Obando

HOMETOWN: Colombia

CURRENT NEIGHBORHOOD: Harlem, Manhattan

CURRENT AGE: 46

AGE AT TRANSITION: 44

PREFERRED PRONOUN(S): He/him

CAREER/JOB: Graphic designer

RELATIONSHIP STATUS: Single

WHAT WAS YOUR PATH TO TRANSITION LIKE?

My transition has been slow because I decided to chance [it] at forty-four, but it was the best decision I have made.

WHAT ARE INTERESTING THINGS ABOUT YOU? WHAT MAKES YOU AS A PERSON UNIQUE?

I am a strong warrior person, and despite the situation I try to be cheerful, and what makes me unique is that I am a funny person.

WHAT WOULD YOU LIKE PEOPLE TO KNOW ABOUT YOURSELF AS A TRANSGENDER PERSON THAT MIGHT BE VERY DIFFERENT FROM PEOPLE'S IDEAS OF TRANS PEOPLE?

That we are ordinary people like others, that we dream, that we have feelings, needs, and aspirations to go far like any other [person].

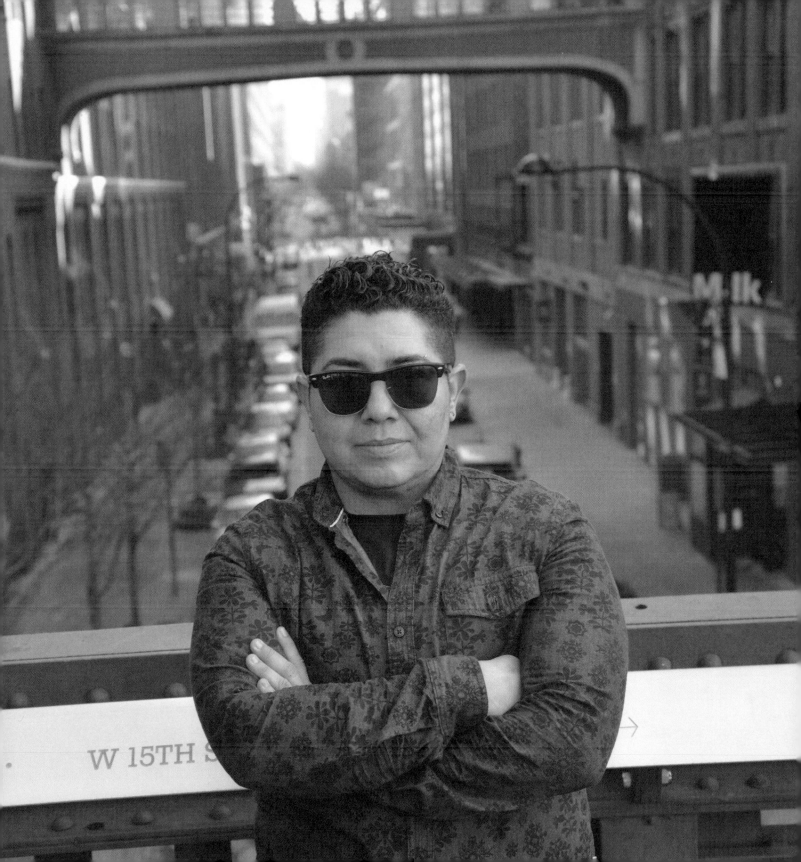

KALIX JACOBSON

NAME (FIRST AND/OR LAST): Kalix Jacobson

HOMETOWN: St. Louis, Missouri

CURRENT NEIGHBORHOOD: Washington Heights, Manhattan

CURRENT AGE: 23

AGE AT TRANSITION: 14 when I came out, 19 when I changed my name

PREFERRED PRONOUN(S): They/them

CAREER/JOB: Student cantor (like a singing rabbi)

RELATIONSHIP STATUS: Single

WHAT WAS YOUR PATH TO TRANSITION LIKE?

I always knew something wasn't quite right with me regarding gender. I remember being as young as six or seven and sitting down in the middle of an Old Navy and crying because I didn't want to try on dresses. I wasn't completely tomboyish, just very fluid in my presentation. I identified as gender-fluid starting at fourteen, then realized I have more of a fluid presentation rather than gender. I started identifying as nonbinary and changed my name to Kalix when I was nineteen.

WHAT ARE INTERESTING THINGS ABOUT YOU? WHAT MAKES YOU AS A PERSON UNIQUE?

I am a future member of clergy that is also gay and nonbinary! I believe strongly in my religion and what it stands for, and I believe there is a place for religious queer and trans individuals.

WHAT WOULD YOU LIKE PEOPLE TO KNOW ABOUT YOURSELF AS A TRANSGENDER PERSON THAT MIGHT BE VERY DIFFERENT FROM PEOPLE'S IDEAS OF TRANS PEOPLE?

I am a very patient and forgiving person. I understand some peoples' issues with other folks' abilities to learn new pronouns, names, etc. I believe that compassion in many cases is more effective than militancy—though I do believe there is a place for [militancy]. I also do not experience frequent dysphoria—though I do occasionally.

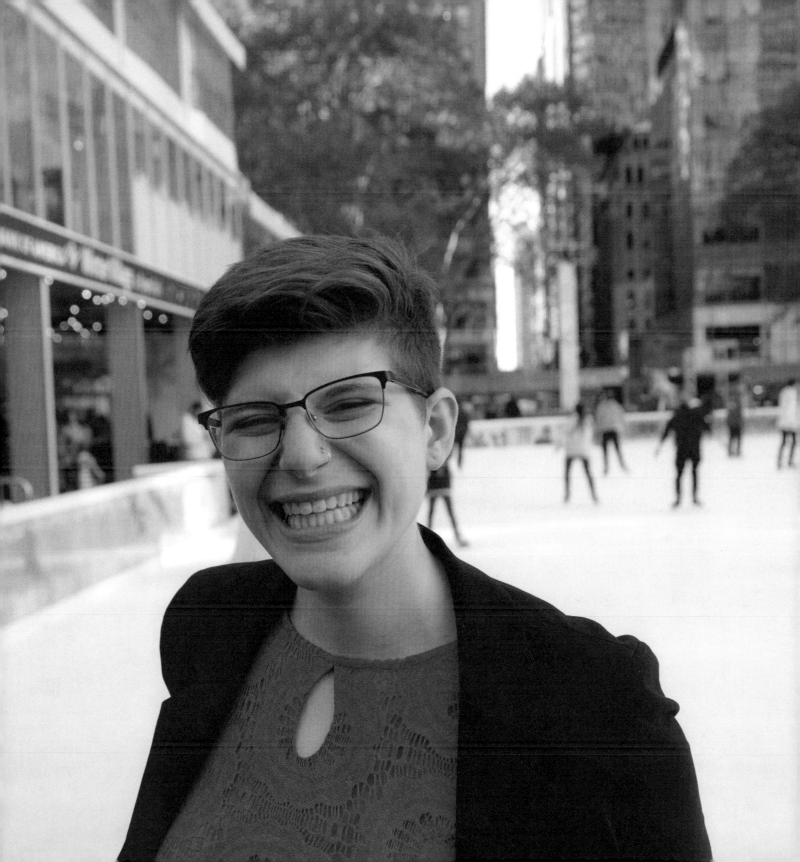

KRISTEN P. LOVELL

NAME (FIRST AND/OR LAST): Kristen P. Lovell

HOMETOWN: Yonkers, Westchester County

CURRENT NEIGHBORHOOD: Flatbush, Brooklyn

CURRENT AGE: —

AGE AT TRANSITION: 19

PREFERRED PRONOUN(S): She/her

CAREER/JOB: Actor/filmmaker

RELATIONSHIP STATUS: Single

WHAT WAS YOUR PATH TO TRANSITION LIKE?

Transitioning wasn't easy. When I first started, there were no healthcare initiatives as there are today, so [I] would pay out of pocket for hormones. There was a pharmacy in Brooklyn [where] we didn't need a prescription. Unfortunately, trying to find work was a struggle when people were actively able to discriminate.

WHAT ARE INTERESTING THINGS ABOUT YOU? WHAT MAKES YOU AS A PERSON UNIQUE?

I have loved filmmaking since I can remember. I can recite all of the *Into the Woods* musical.

WHAT WOULD YOU LIKE PEOPLE TO KNOW ABOUT YOURSELF AS A TRANSGENDER PERSON THAT MIGHT BE VERY DIFFERENT FROM PEOPLE'S IDEAS OF TRANS PEOPLE?

That we have every right to live as we are without fear. That our lives matter just as much as the next person's. And I'm worthy of love from whomever I choose.

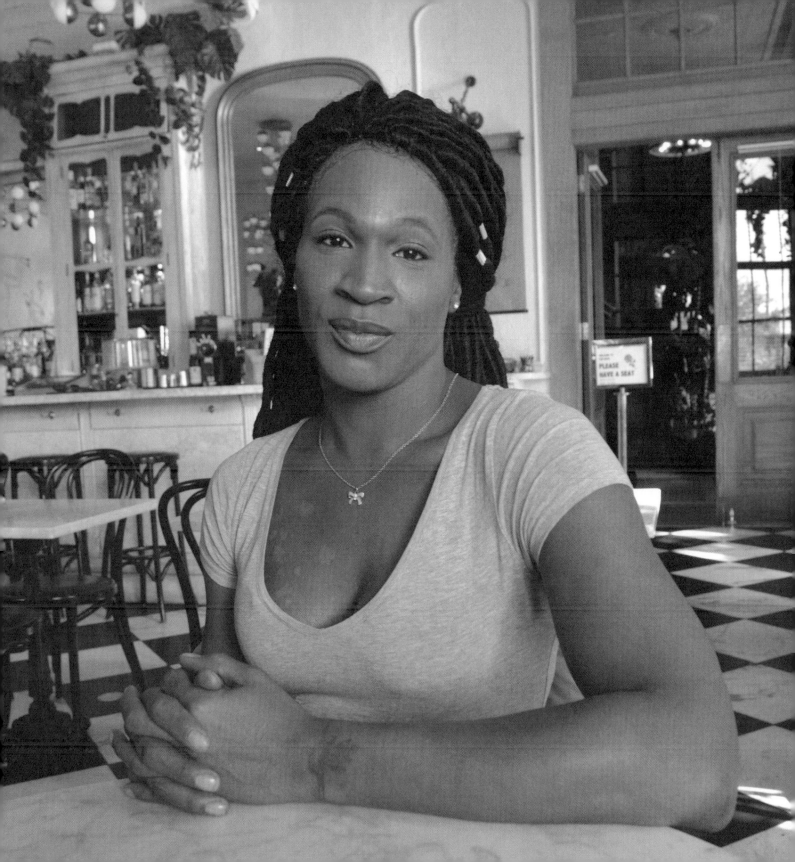

LAURA A. JACOBS

NAME (FIRST AND/OR LAST): Laura A. Jacobs, LCSW-R

HOMETOWN: NYC

CURRENT NEIGHBORHOOD: NYC

CURRENT AGE: 50

AGE AT TRANSITION: MYOB [Mind your own business]

PREFERRED PRONOUN(S): She/he/they/none

CAREER/JOB: Psychotherapist, activist, author, public speaker . . . heretic

RELATIONSHIP STATUS: Single

WHAT WAS YOUR PATH TO TRANSITION LIKE?

Like so many, I knew my gender was different when I was young. I remember a moment where I was five years old and thought, "Why can't they make me the girl I was meant to be?"

And like so many, I hid this awareness from others and often even from myself, something that only led [me] to deep depression and hopelessness.

My therapist was clueless. Much of our therapy was problematic, like his refusal to educate himself on transgender issues or him withholding the letter authorizing hormones because he felt I wasn't giving enough consideration to the loss of fertility. (I sidestepped and started anyhow.) But although I didn't have much guidance, the situation offered the opportunity to fashion my identity and expression outside any predetermined narrative of what trans identity "should" be.

Over time I began to think of my being trans differently . . . rather than rush to surgery as the end goal of transition, I questioned one aspect of gender, made a decision how to proceed, then moved on and questioned another, decided, then another . . . and now regard myself as trans and genderqueer, meaning that my gender exists outside binaries, that both and neither "male" and "female" apply. I delight in confronting gender stereotypes through my presentation and expression. I don't care what pronouns people use for me. And I consider my gender to be the product of nonjudgmental exploration.

(continued on page 139)

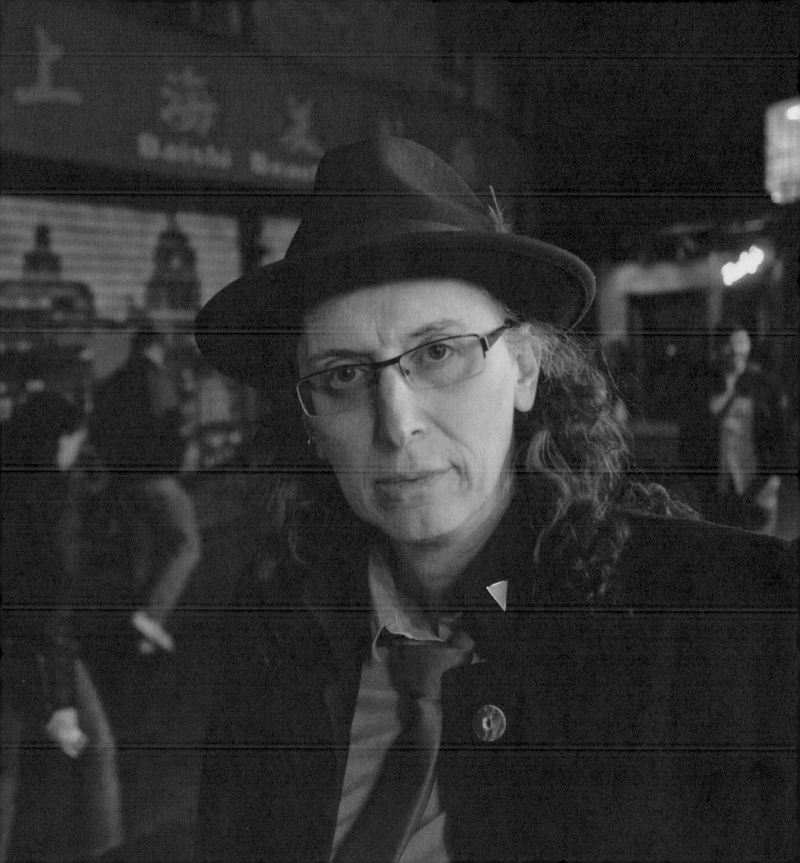

LESTER ESMOND DALE

NAME (FIRST AND/OR LAST): Lester Esmond Dale

HOMETOWN: Brooklyn

CURRENT NEIGHBORHOOD: Pelham Bay Park, Bronx

CURRENT AGE: 57

AGE AT TRANSITION: 47

PREFERRED PRONOUN(S): He/him/his

CAREER/JOB: Actor

RELATIONSHIP STATUS: Married

WHAT WAS YOUR PATH TO TRANSITION LIKE?

Emotionally painful, way too late in life.

WHAT ARE INTERESTING THINGS ABOUT YOU? WHAT MAKES YOU AS A PERSON UNIQUE?

I have been a baseball umpire and football referee for thirty-six years. I went back to college late in life, became a scholar, and am incurably romantic.

WHAT WOULD YOU LIKE PEOPLE TO KNOW ABOUT YOURSELF AS A TRANSGENDER PERSON THAT MIGHT BE VERY DIFFERENT FROM PEOPLE'S IDEAS OF TRANS PEOPLE?

I believe I was born deformed. The process isn't something you decide to do one morning. You fight your entire life to be seen as you truly are. The process waxes and wanes.

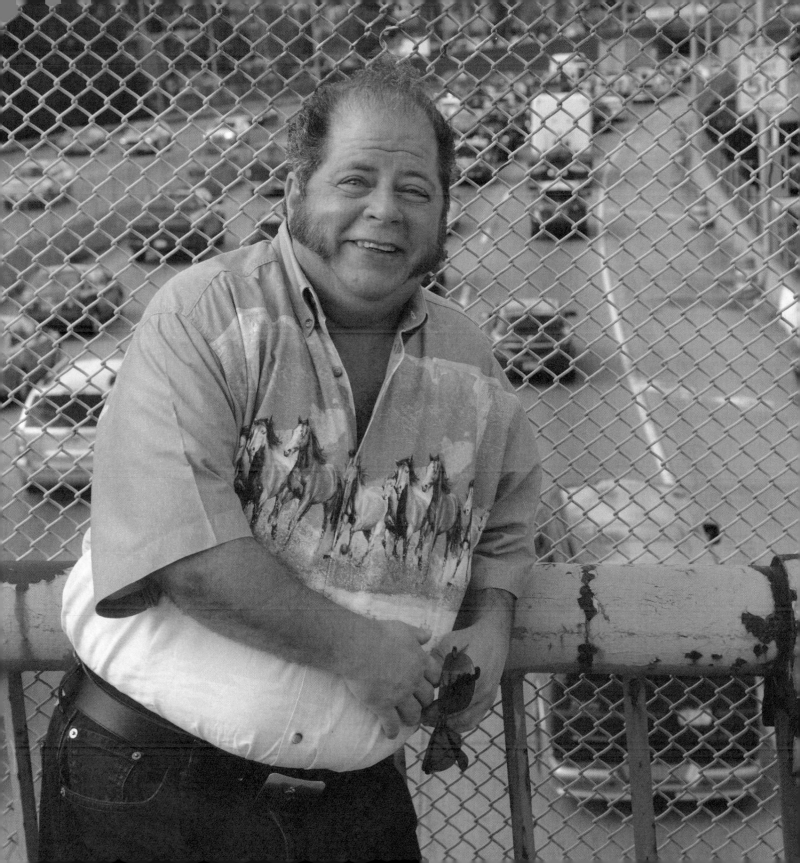

LINDA LABEIJA

NAME (FIRST AND/OR LAST): Linda LaBeija

HOMETOWN: Bronx

CURRENT NEIGHBORHOOD: New York City

CURRENT AGE: 29

AGE AT TRANSITION: 22

PREFERRED PRONOUN(S): She/her

CAREER/JOB: Multidisciplinary artist, curator, teacher

RELATIONSHIP STATUS: Open relationship of one year

WHAT WAS YOUR PATH TO TRANSITION LIKE?

It was more of an awakening. Soon after, it became a spiritual journey. It took many years to awaken. Then many more years to become who I wanted [to be] and dreamed of being. My transition has been rooted in discovering my beauty, self-esteem, and individual path in spirit, in profession, in community.

WHAT ARE INTERESTING THINGS ABOUT YOU? WHAT MAKES YOU AS A PERSON UNIQUE?

I am alive and have my work archived in a museum. More of a blessing than something interesting. I began playing the drum again recently. Have also started drawing again. I'm Puerto Rican and Antiguan.

WHAT WOULD YOU LIKE PEOPLE TO KNOW ABOUT YOURSELF AS A TRANSGENDER PERSON THAT MIGHT BE VERY DIFFERENT FROM PEOPLE'S IDEAS OF TRANS PEOPLE?

I am not a sex object. I have grown tired of being desired only for sex. The way people view transgender women greatly impacts my success. It has affected the roles I get [called] back for, the opportunities I'm afforded, and the amount of money I make. I don't believe in hiding who I am or diminishing it. I don't believe in apologizing for it or explaining it. I am existing just like everyone else. To know me is a privilege. And that's how high I must keep my ideas of self-worth. Because this world is out to use me.

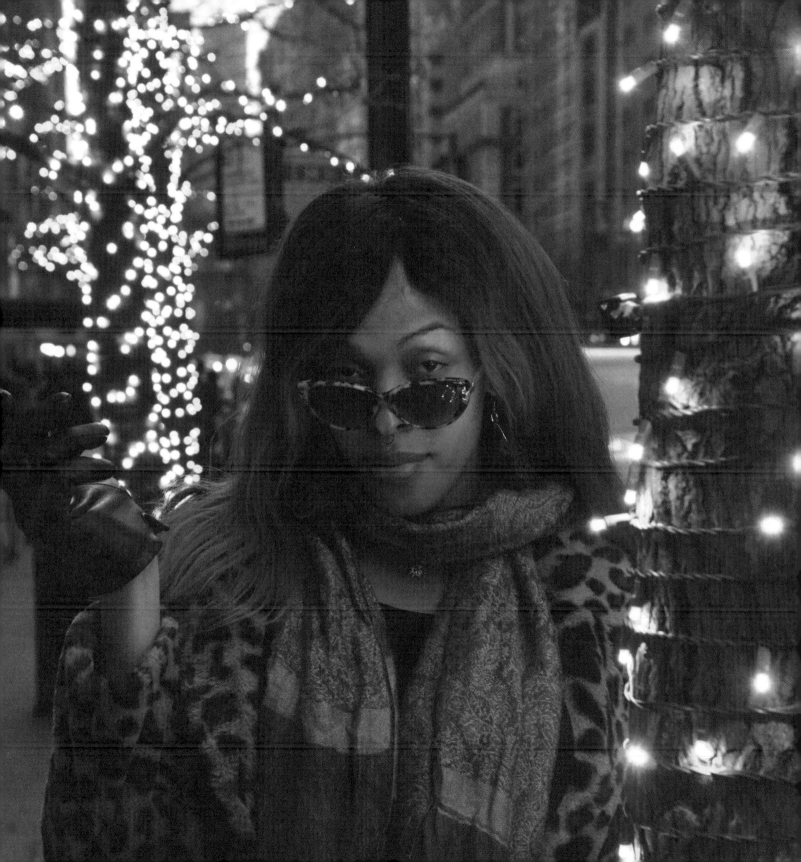

LOGANN GRAYCE

NAME (FIRST AND/OR LAST): Logann Grayce

HOMETOWN: Monroe Township, New Jersey

CURRENT NEIGHBORHOOD: West New York, New Jersey

CURRENT AGE:

AGE AT TRANSITION:

PREFERRED PRONOUN(S): They/them

CAREER/JOB: Actor/writer/mentor

RELATIONSHIP STATUS: Single

WHAT WAS YOUR PATH TO TRANSITION LIKE?

Very late and gradual. I didn't have access to the language for what I knew to be my gender until a few years ago. Once I started meeting gender-fluid, transgender, and nonbinary people, I really started to know myself better.

WHAT ARE INTERESTING THINGS ABOUT YOU? WHAT MAKES YOU AS A PERSON UNIQUE?

People seem surprised to see me crochet. I survived a near-death surgical mishap. I am unique because I have always had my own sense of style that is always evolving. I've always found it better to be true to myself than worry about what others will think. I am blatantly honest.

WHAT WOULD YOU LIKE PEOPLE TO KNOW ABOUT YOURSELF AS A TRANSGENDER PERSON THAT MIGHT BE VERY DIFFERENT FROM PEOPLE'S IDEAS OF TRANS PEOPLE?

I am not a freak or weirdo because I am transgender. Being trans is not made up or a mental illness. I am powerful and loving and considerate. I am a babysitter, dear and loyal friend, a parent to two sweet cats. My gender and gender expression don't define who I am as a human being.

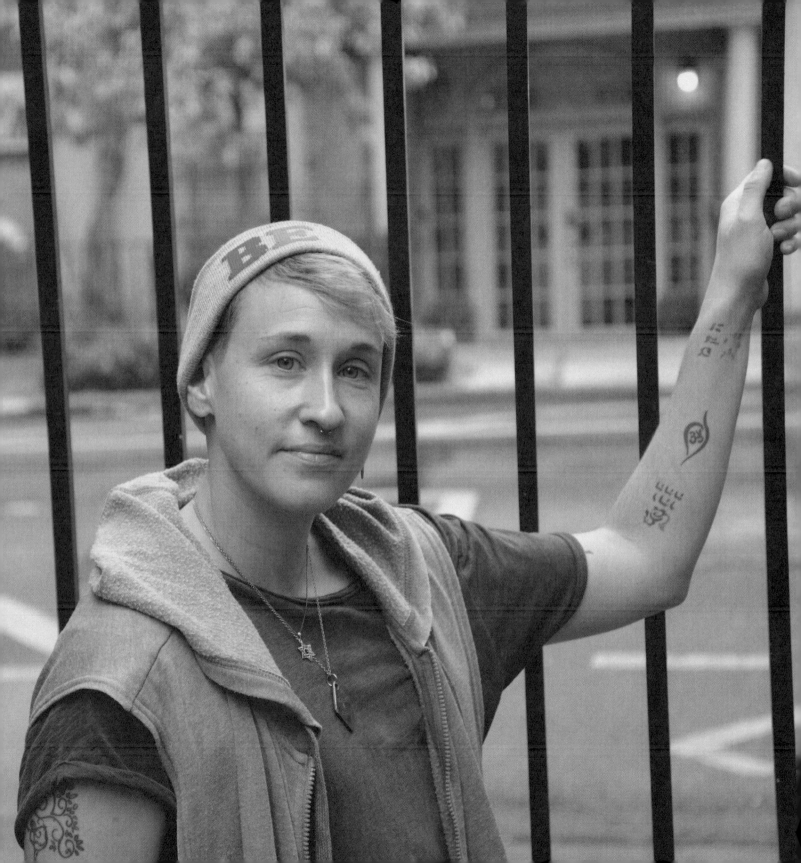

LUCAS DYLAN RABINOWITZ

NAME (FIRST AND/OR LAST): Lucas Dylan Rabinowitz

HOMETOWN: Long Island

CURRENT NEIGHBORHOOD: Sunnyside, Queens

CURRENT AGE: 25

AGE AT TRANSITION: 24

PREFERRED PRONOUN(S): He/him

CAREER/JOB: Artist

RELATIONSHIP STATUS: Single

WHAT WAS YOUR PATH TO TRANSITION LIKE?

I first knew I was a boy at the age of three. As I grew, I was led closer to my truth, even though I didn't have the language or representation to understand I was transgender. I remember sitting on a school bus and dreaming of having a son when I was very young. I heard in my head, as I got older, the name he'd be given, which was Lucas Dylan. That is the name I gave myself at twenty-four. My transition has been the return to who I've always been.

WHAT ARE INTERESTING THINGS ABOUT YOU? WHAT MAKES YOU AS A PERSON UNIQUE?

I see femininity on a male spectrum. I enjoy being a man who is soft, tender, nurturing, and gentle.

WHAT WOULD YOU LIKE PEOPLE TO KNOW ABOUT YOURSELF AS A TRANSGENDER PERSON THAT MIGHT BE VERY DIFFERENT FROM PEOPLE'S IDEAS OF TRANS PEOPLE?

I am currently not on testosterone and I'm not sure if I will ever go on it. I want people to know that doesn't make me less of a man. I also don't bind my chest, which doesn't make me any less transgender.

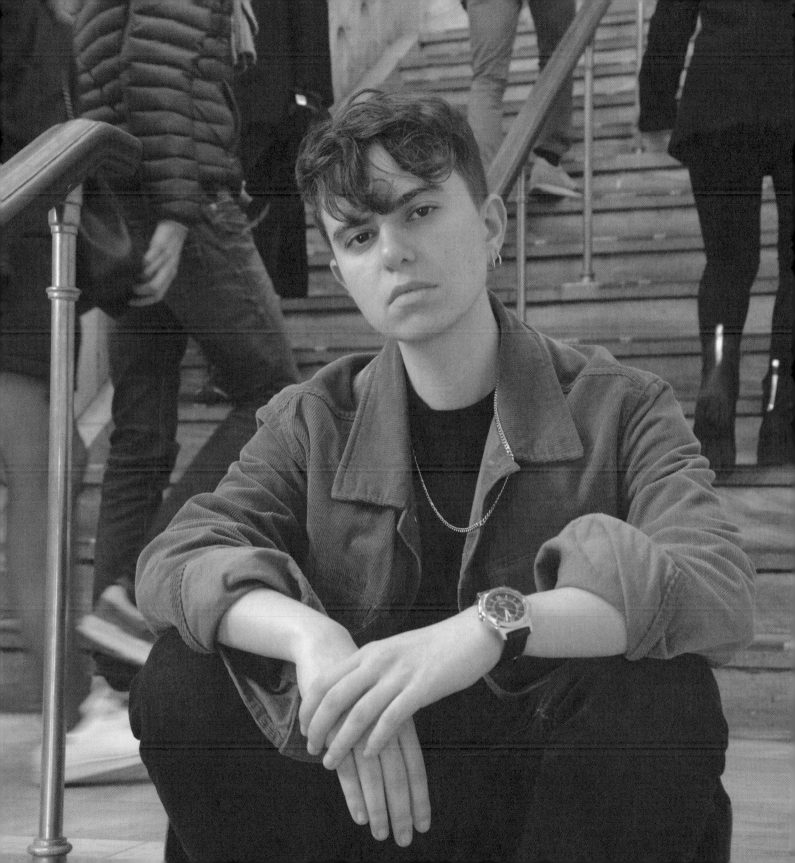

MASON WOOD

NAME (FIRST AND/OR LAST): Mason Wood

HOMETOWN: Pretoria, South Africa

CURRENT NEIGHBORHOOD: Bedford-Stuyvesant, Brooklyn

CURRENT AGE: 27

AGE AT TRANSITION: 25

PREFERRED PRONOUN(S): He/him

CAREER/JOB: Off the books

RELATIONSHIP STATUS: Married

WHAT WAS YOUR PATH TO TRANSITION LIKE?

It was tumultuous. Back in South Africa I was shunned for who I was. I came to the United States for work and through friends I made, found an opportunity to truly start my transition. My job initially wasn't very supportive, and at times still isn't, but I've gotten the freedom to become myself surrounded by people who love me and support me.

WHAT ARE INTERESTING THINGS ABOUT YOU? WHAT MAKES YOU AS A PERSON UNIQUE?

I have synesthesia (one sense is simultaneously perceived as if by additional senses), I have a degree in philosophy, ancient culture studies, and psychology, and I am an avid gamer. I believe that as a person I am unique because I've overcome a lot in life yet still want to listen to, support, and help others.

WHAT WOULD YOU LIKE PEOPLE TO KNOW ABOUT YOURSELF AS A TRANSGENDER PERSON THAT MIGHT BE VERY DIFFERENT FROM PEOPLE'S IDEAS OF TRANS PEOPLE?

Every day brings forth its own anxieties that are just like those of cisgender people. Navigating relationships, jobs, bills, friendships, going out, etc.; these are exactly like everybody else regardless of how one identifies. I don't want to shove my choices down anybody's throat, I just want to exist and live my best life possible. I want the American Dream.

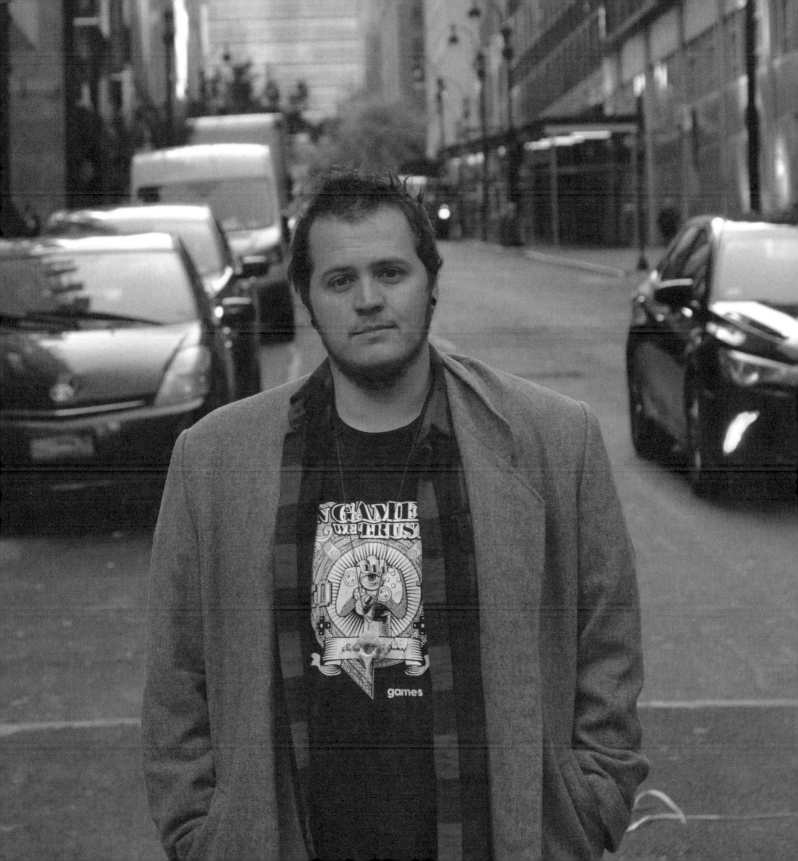

MELISSA SKLARZ

NAME (FIRST AND/OR LAST): Melissa Sklarz

HOMETOWN: New York City

CURRENT NEIGHBORHOOD: Woodside, Queens

CURRENT AGE: Over 55

AGE AT TRANSITION: Over 33

PREFERRED PRONOUN(S): She/her

CAREER/JOB: Government relations, SAGE

RELATIONSHIP STATUS: Single

WHAT WAS YOUR PATH TO TRANSITION LIKE?

I started [transitioning] in 1991, after years of struggling and suffering. After a substance abuse history made me homeless, I started my transition, as I had little to lose.

WHAT ARE INTERESTING THINGS ABOUT YOU? WHAT MAKES YOU AS A PERSON UNIQUE?

I am friendly, smart, funny, hardworking, and committed to neighborhood and community. I have been involved in politics and community support for over twenty years, I ran for public office in 2018, and I've held political posts since the late 1990s. I was in the movie *Transamerica* in 2005. I was elected to the Big Apple Softball League Hall of Fame in 2019. I was a delegate to the Democratic National Convention in 2016. I transitioned before people had computers.

WHAT WOULD YOU LIKE PEOPLE TO KNOW ABOUT YOURSELF AS A TRANSGENDER PERSON THAT MIGHT BE VERY DIFFERENT FROM PEOPLE'S IDEAS OF TRANS PEOPLE?

I do not know what people's ideas of a trans person are. I work nine-to-five and I have since 1997. I am attractive and somewhat out as trans.

This book is a wonderful opportunity for cisgender people to embrace the range and beauty of a mostly unseen community and to realize that trans people are people and deserve love and respect like everyone else.

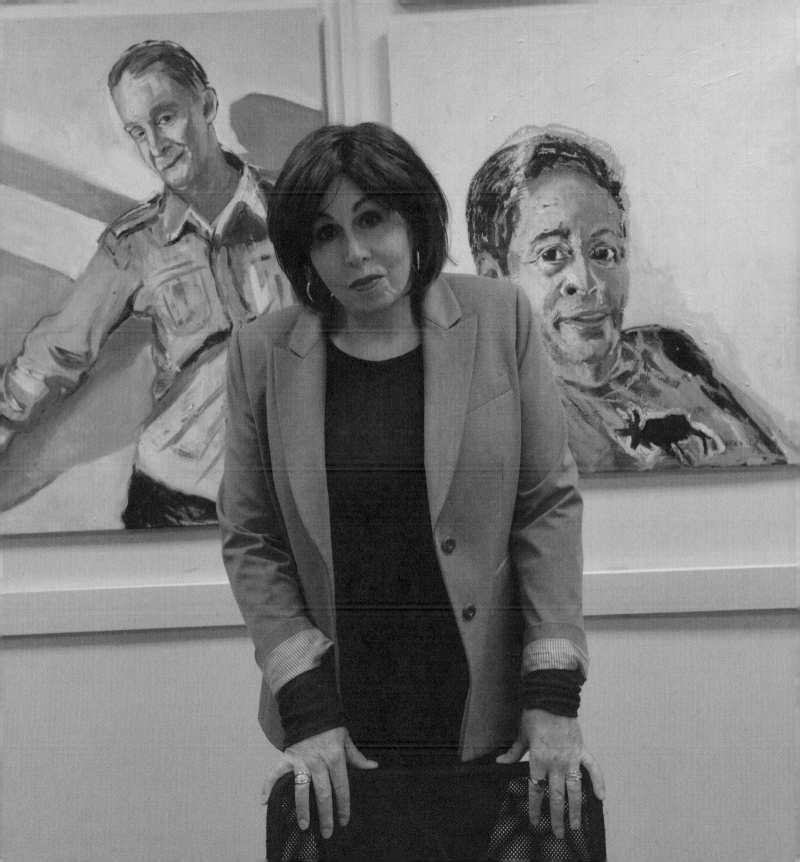

MIRANDA MIRANDA

NAME (FIRST AND/OR LAST): Miranda Miranda

HOMETOWN:

CURRENT NEIGHBORHOOD: Staten Island

CURRENT AGE: 29

AGE AT TRANSITION: 25

PREFERRED PRONOUN(S): She/her

CAREER/JOB: Modeling, photography

RELATIONSHIP STATUS: Totally in love

WHAT WAS YOUR PATH TO TRANSITION LIKE?

My transition hasn't been easy since there is a lot of discrimination in my home country of Mexico, so I had to live here in New York to become who I am meant to be. Being in New York and transitioning is a bit more comfortable as it's more queer friendly and progressive.

WHAT ARE INTERESTING THINGS ABOUT YOU? WHAT MAKES YOU AS A PERSON UNIQUE?

Lo interesante es cuando estaba en la escuela que siempre me gustaba salir en festivales, tratando de sentirme e se estrella que quería brillar. Soy y me considero única por mi esencia y pasión al amar a las personas, soy de esas personas que nunca se rinde en logras lo que me propongo.

The interesting thing is that when I was in school, I was very interested in going to parties, trying to feel like a star who wanted to shine. I consider myself to be quite a unique person because of my sense of self and passion for other people. I'm the type of person who never gives up on the goals I set for myself.

WHAT WOULD YOU LIKE PEOPLE TO KNOW ABOUT YOURSELF AS A TRANSGENDER PERSON THAT MIGHT BE VERY DIFFERENT FROM PEOPLE'S IDEAS OF TRANS PEOPLE?

No se rindan, nunca es tarde para comenzar algo que siempre se ha querido. La vida es muy corta y a veces so sabemos cómo disfrutarla. Yo soy una persona muy positiva y sé que quieres es poder. Estoy cumpliendo mis sueños en New York. Estoy aquí para gritar al mundo y sobre todo a mí misma que todo es posible. Si.

(continued on page 140)

Opposite: Derek James (left) and Miranda Miranda (right)

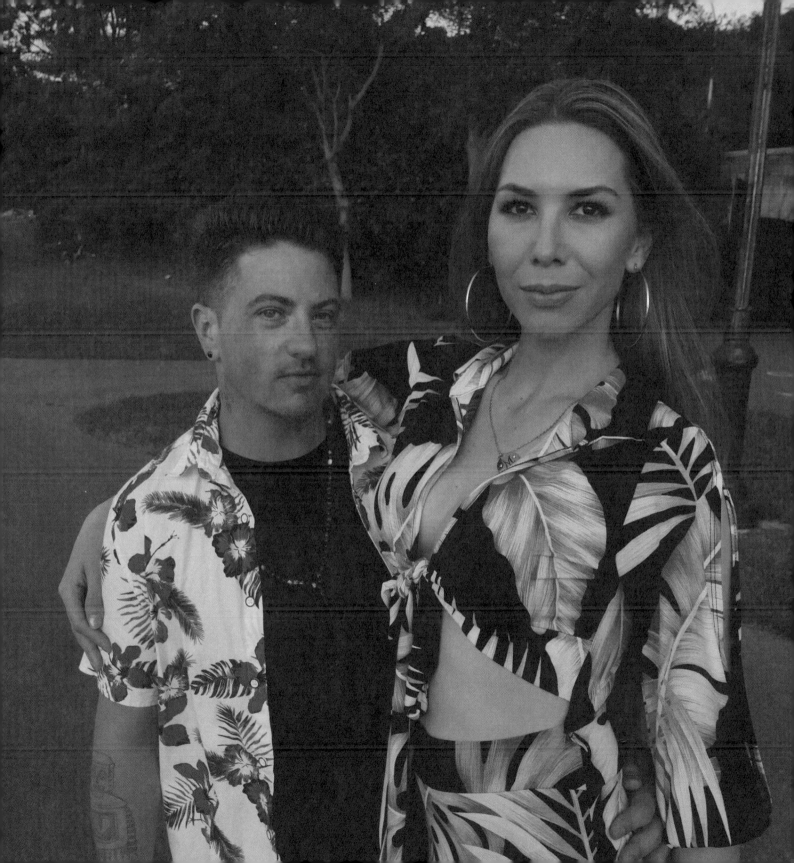

NATASHA ARTIS

NAME (FIRST AND/OR LAST): Natasha Artis

HOMETOWN: Staten Island

CURRENT NEIGHBORHOOD: Times Square, Manhattan

CURRENT AGE: 37

AGE AT TRANSITION: 23

PREFERRED PRONOUN(S): They/them

CAREER/JOB: Unemployed

RELATIONSHIP STATUS: Single

WHAT WAS YOUR PATH TO TRANSITION LIKE?

Kind of smooth. I stayed true to my idea of a woman.

WHAT ARE INTERESTING THINGS ABOUT YOU? WHAT MAKES YOU AS A PERSON UNIQUE?

My strength and confidence.

WHAT WOULD YOU LIKE PEOPLE TO KNOW ABOUT YOURSELF AS A TRANSGENDER PERSON THAT MIGHT BE VERY DIFFERENT FROM PEOPLE'S IDEAS OF TRANS PEOPLE?

I'm a rebel to society's standards of what a trans woman should look like.

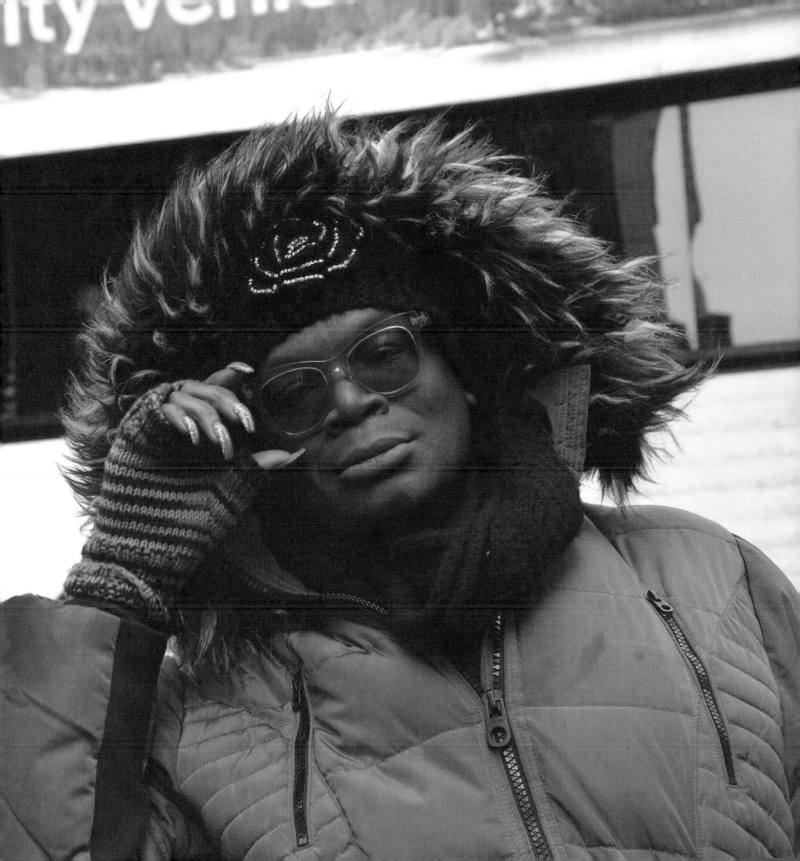

PEARL LOVE

NAME (FIRST AND/OR LAST): Pearl Love

HOMETOWN: Taiwan

CURRENT NEIGHBORHOOD: Williamsburg, Brooklyn

CURRENT AGE: None of your damn business

AGE AT TRANSITION:

PREFERRED PRONOUN(S): She/her

CAREER/JOB: Translatinx Network

RELATIONSHIP STATUS: Single

WHAT WAS YOUR PATH TO TRANSITION LIKE?

這是一個非常艱難的決定。過渡非常艱鉅,但值得為了自己而奮鬥。

It was a very difficult decision to make. The transition was so dramatic but it's worth it to fight to be myself.

WHAT ARE INTERESTING THINGS ABOUT YOU? WHAT MAKES YOU AS A PERSON UNIQUE?

成長是如此的不同。 爭取性別認同。 我一直在努力改變自己成為別人,到現在為止我很容易成為自己。 我認為我的跨性別生活經歷和成為我自己的意願使我與眾不同。

Being so different growing up, struggling with my gender identity. I was always trying to change myself to be someone else, but now I am comfortable being myself. I think my trans life experience and a willingness to be myself make me unique.

WHAT WOULD YOU LIKE PEOPLE TO KNOW ABOUT YOURSELF AS A TRANSGENDER PERSON THAT MIGHT BE VERY DIFFERENT FROM PEOPLE'S IDEAS OF TRANS PEOPLE?

您希望人們如何了解自己作為跨性別者,而這從人們對跨性別者的觀念中可能很難做到。

就像平等對待我們一樣對待其他人一樣。 但是我知道對於很多人來說還是很困難的。

Simply put, just treat us like everyone else, with equal opportunity. But I know it's still very difficult for a lot of people.

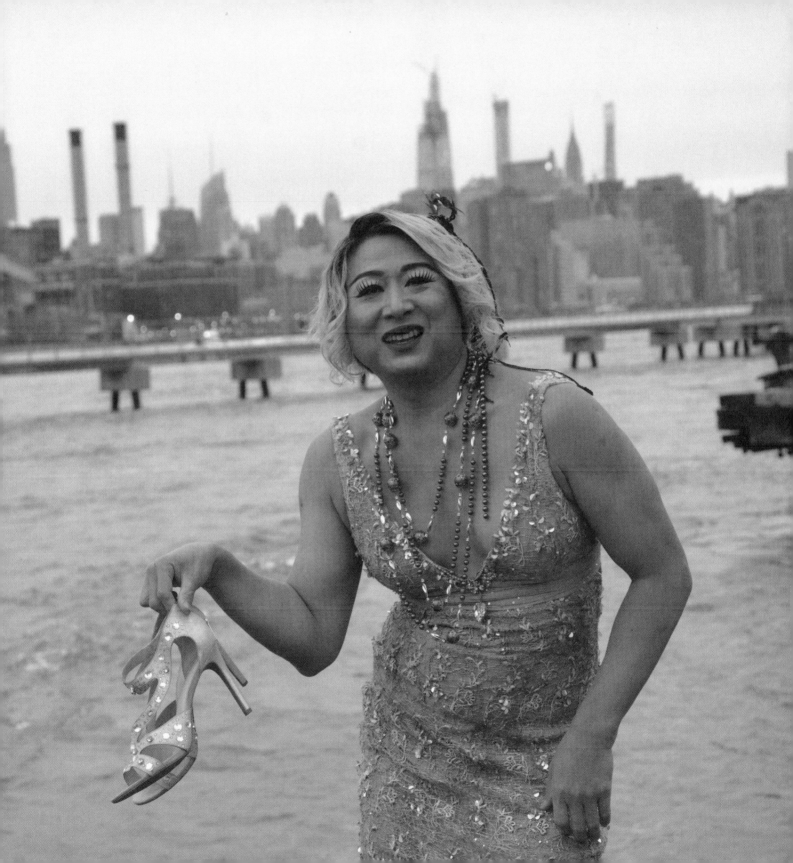

POOYA MOHSENI

NAME (FIRST AND/OR LAST): Pooya Mohseni

HOMETOWN: Iran/Tehran

CURRENT NEIGHBORHOOD: Midtown, Manhattan

CURRENT AGE: 41

AGE AT TRANSITION: 19

PREFERRED PRONOUN(S): She/her

CAREER/JOB: Actor, writer, filmmaker, healer

RELATIONSHIP STATUS: Depends who's asking

WHAT WAS YOUR PATH TO TRANSITION LIKE?

Well, I took on a traditional, conservative, Middle Eastern culture—with its antiquated ideas about gender roles—and defied it in the late eighties and nineties, before the term "transgender" was something people used or even knew what it meant exactly. It's been a journey of self-doubt, assault, suicide attempts, dark days and nights, blind faith, and human resilience. In other words, it's a story of self-discovery, growth, and staying focused on who I've always known myself to be: a woman, of transgender experience.

WHAT ARE INTERESTING THINGS ABOUT YOU? WHAT MAKES YOU AS A PERSON UNIQUE?

It's hard to say what makes one unique, because I'm not unique to myself as I've known myself all my life. But I think the qualities that make me like who I am, are those I like in people who inspired me to be . . . well, me! I say what I believe and am always open to knowing more and admitting when I'm wrong. I don't make promises I can't keep and if I make them, I keep them. I believe we all have a part in making the world a better place and as someone who has seen war, violence, and inequality up close and personal, I believe the only way to have a better world is if we aspire to [fulfill] the better parts of our nature and take the high road, rather than give in to our most basic instincts and have a race to the bottom. No one wins in that situation. I admire strong people, kind people, those who share of themselves, those who believe that only if we come together, do we stand a chance to create the world as it should be, as it can be and not just as is. With all that said, I don't know if that makes me unique or not, but it is unabashedly and genuinely me, and every day, I try to be a slightly better version of myself, because you know: we never stop growing!

(continued on page 141)

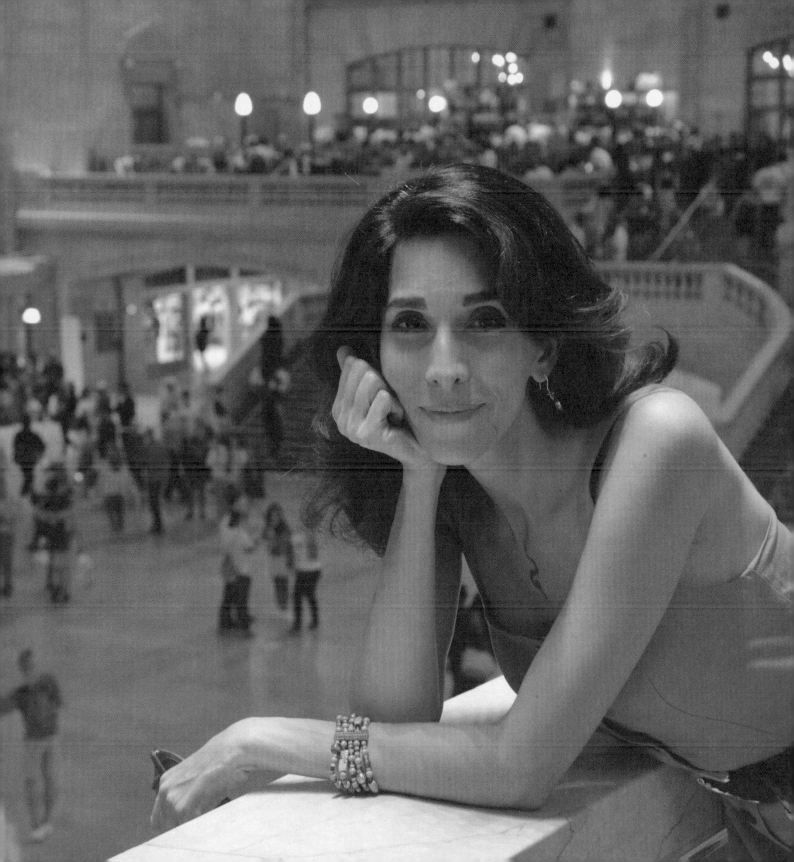

PRESTON ALLEN

NAME (FIRST AND/OR LAST): Preston Allen

HOMETOWN: Fort Worth, Texas

CURRENT NEIGHBORHOOD: Hamilton Heights, Manhattan

CURRENT AGE: 26

AGE AT TRANSITION: 24

PREFERRED PRONOUN(S): He/him

CAREER/JOB: Musical theater writer

RELATIONSHIP STATUS: Single

WHAT WAS YOUR PATH TO TRANSITION LIKE?

My relationship with my body has always been extremely complicated, and in trying to reconcile it I unfortunately lost a lot of my teen years to shame, anxiety, and extreme discomfort. I always knew I was a part of the LGBT community, but growing up in Texas I could only find much of that representation in media, and there was little to no trans presence in the content I was watching. I threw myself into my career as a distraction from my mental health, but as I gained more traction, I still couldn't stand with any joy in a room celebrating my work. In 2017, I started working at The Trevor Project, and in training to help others learn to understand and love themselves, I had

to face what I'd been going through too. The minute I decided to let transitioning become a real possibility, there was an incredibly hopeful, healthy clarity that I knew what I'd been missing. I'm so lucky that my family has been supportive, because it's made this is a very safe, very careful, and open process that I wish everyone who needs to could experience.

WHAT ARE INTERESTING THINGS ABOUT YOU? WHAT MAKES YOU AS A PERSON UNIQUE?

I'd love to think I'm unique, but I've honestly found so many friends who share the same bizarre quirks and worldviews that I've come to love how much I share with others. Although I think I'm the only one with an *E.T.* collection. . . . But on a slightly more personal note, I love writing music and telling stories that blend comedy and tragedy and hopefully connect a little bit to people who want to know they're not alone in a troubling feeling or a really bad day, and that hopefully help people find ways to face and work through these really difficult moments. As I learned growing up, art can be advocacy, even if it's a silly romance between two people you don't normally see fall in love on-screen. I aim to be a voice in that through what I hope turns out to be many different stories.

(continued on page 142)

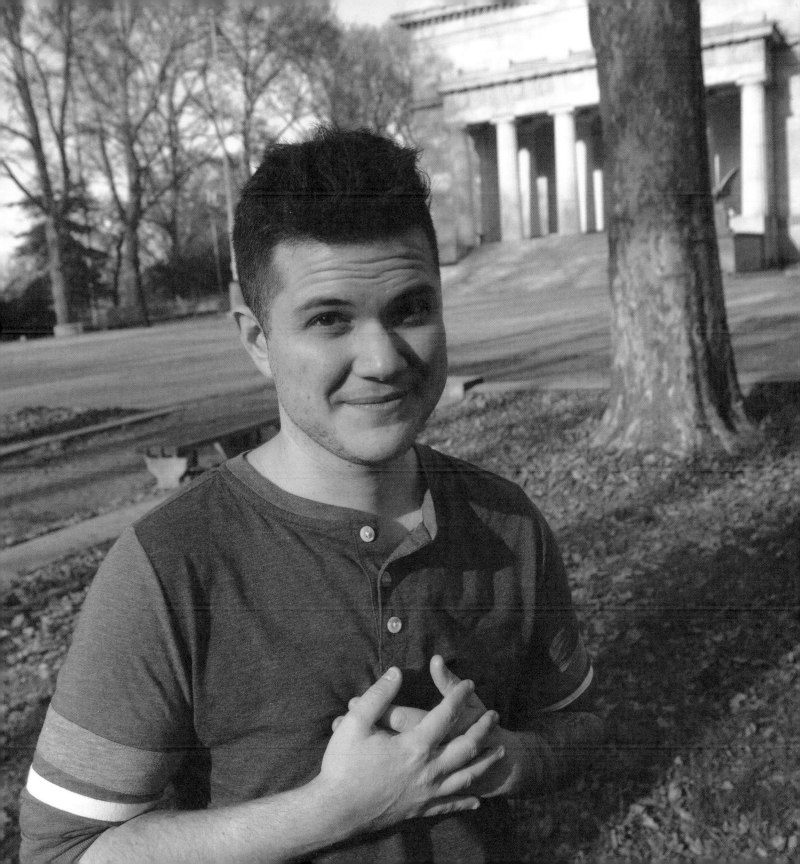

RAVEN ELIZABETH

NAME (FIRST AND/OR LAST): Raven Elizabeth

HOMETOWN: Ocala, Florida

CURRENT NEIGHBORHOOD: New York City

CURRENT AGE: 39

AGE AT TRANSITION: 23

PREFERRED PRONOUN(S): She/her

CAREER/JOB: Hairstylist

RELATIONSHIP STATUS: Married

WHAT WAS YOUR PATH TO TRANSITION LIKE?

My transition was pretty easy compared to most because I had an accepting family. What I didn't have was information. I came out as gay thinking all gay men felt like they were really women. I learned I was wrong when I was eighteen and learned what transgender was. When I went out into the LGBT world, I started performing drag, which allowed me to, at least for a moment, be the real me.

With the support of my family and friends and coming to the conclusion that being a drag performer made me feel less like a woman eventually and more like a spectacle, I decided to transition and it was the best thing I ever did.

WHAT ARE INTERESTING THINGS ABOUT YOU? WHAT MAKES YOU AS A PERSON UNIQUE?

I think everybody is unique. However, if I did have to choose something, I would say that the most unique thing about me is caring less about what others accept and caring more about what I accept of myself.

WHAT WOULD YOU LIKE PEOPLE TO KNOW ABOUT YOURSELF AS A TRANSGENDER PERSON THAT MIGHT BE VERY DIFFERENT FROM PEOPLE'S IDEAS OF TRANS PEOPLE?

I think that everyone should know that I don't need anyone's permission to be happy and to be authentic.

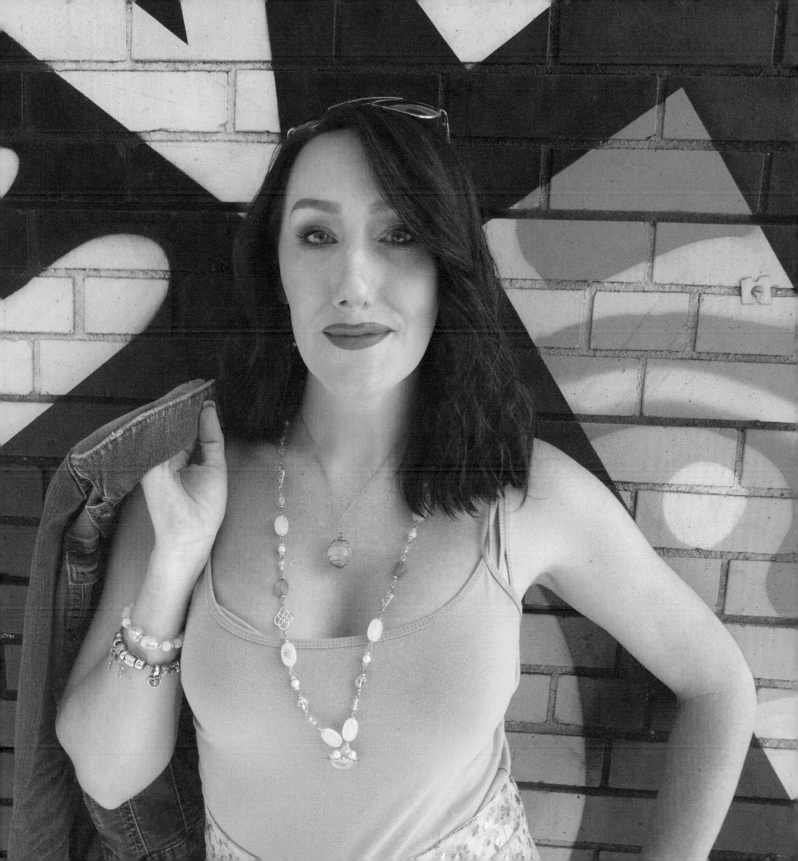

RAYNE VALENTINE

NAME (FIRST AND/OR LAST): Rayne Valentine

HOMETOWN: Detroit, Michigan

CURRENT NEIGHBORHOOD: Coney Island, Brooklyn

CURRENT AGE: 31

AGE AT TRANSITION: 30

PREFERRED PRONOUN(S): He/him/his

CAREER/JOB: Junior pitmaster, chef, jack-of-all-trades

RELATIONSHIP STATUS: Dating

WHAT WAS YOUR PATH TO TRANSITION LIKE?

The road to transitioning was hard. I had wrestled with it for years, internally. I'd ask partners how they'd feel if I transitioned, and was met with either recoil, or just dismissal, so it felt like I had to live this lie and that no one would accept me. Last year was probably the worst. I was street homeless, off my meds, [had] no help, and was basically alone and so close to ending my life that I actively sought out drugs to try and OD. Then I met some people who helped me out. They gave me a place to stay, information about transitioning, and helped me regain my footing. They suggested Callen-Lorde, and the

first day I went there and told the staff that I wanted to transition, they started me on T [testosterone] the same day. I was finally feeling like myself and starting to love my life again. From there, things completely changed. I did have to go to a shelter for about eight months, but I eventually got my own apartment. Two weeks later, I got my top surgery. My friends from home drove out from Detroit to come be with me. Then I started at a job that was and is incredibly supportive, with people I've come to love. I'm finally in a place where I'm very happy with myself and my life. I feel accepted by the people closest to me and my family isn't thrilled, but they're happy that I'm happy. Less than a year ago, I never thought I'd get to this point where I can say I finally love myself and am becoming the man I've always been.

WHAT ARE INTERESTING THINGS ABOUT YOU?
WHAT MAKES YOU AS A PERSON UNIQUE?

Umm, this is tough. I honestly don't think I'm that interesting of a person. Umm, well, I am a former Marine; joined at seventeen, right out of high school. I also make glass jewelry, something I learned last year out in Brooklyn.

(continued on page 142)

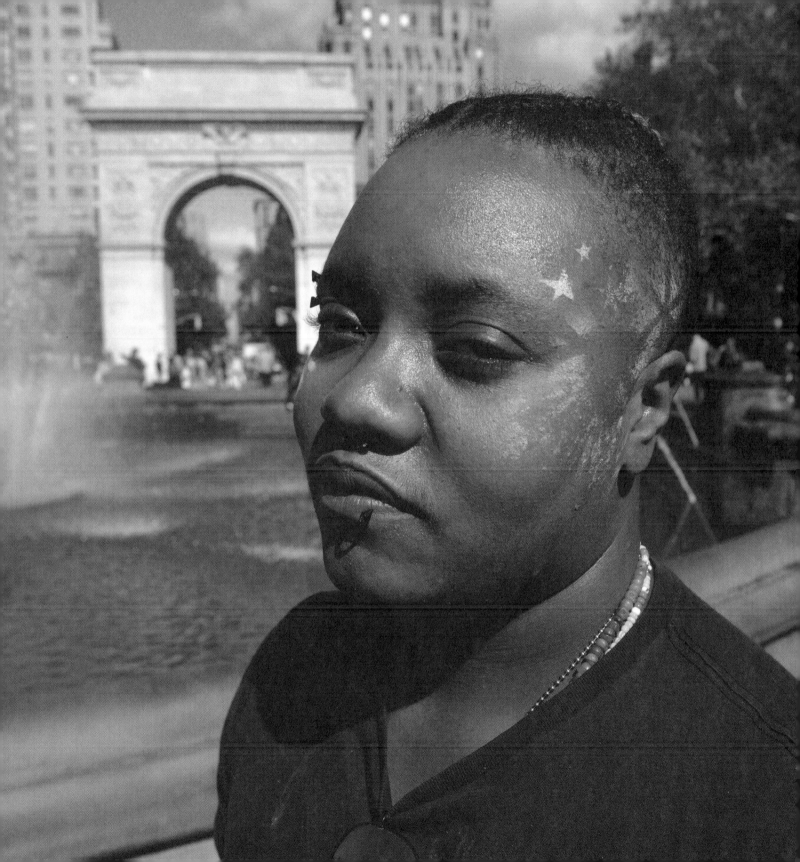

RENATA RAMOS

NAME (FIRST AND/OR LAST): Renata Ramos

HOMETOWN: Soca, Canelones, Uruguay

CURRENT NEIGHBORHOOD: Bronx

CURRENT AGE: 58

AGE AT TRANSITION: 56

PREFERRED PRONOUN(S): She/her/hers

CAREER/JOB: Actress

RELATIONSHIP STATUS: Single

WHAT WAS YOUR PATH TO TRANSITION LIKE?

Easy. At my age you are very comfortable in your own skin. At least I am.

WHAT ARE INTERESTING THINGS ABOUT YOU? WHAT MAKES YOU AS A PERSON UNIQUE?

My extremely exciting history. I don't live life; I eat it up in huge bites.

WHAT WOULD YOU LIKE PEOPLE TO KNOW ABOUT YOURSELF AS A TRANSGENDER PERSON THAT MIGHT BE VERY DIFFERENT FROM PEOPLE'S IDEAS OF TRANS PEOPLE?

Just because my journey has had some privileges doesn't mean you don't hurt or suffer. The privileged also cry.

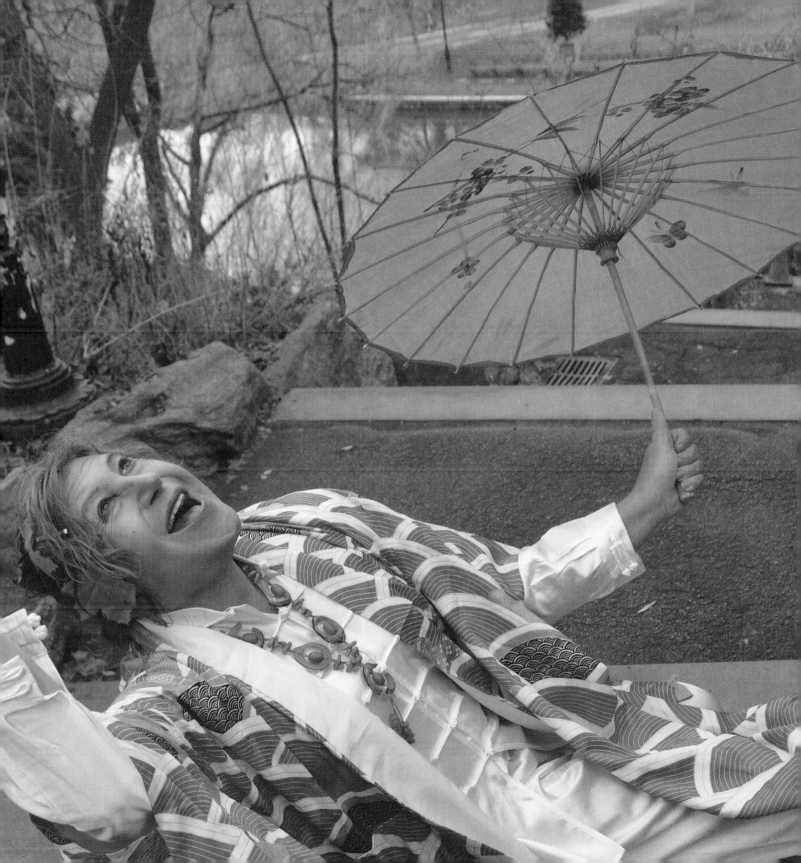

SANDY SAHAR GOOEN

NAME (FIRST AND/OR LAST): Sandy Sahar Gooen

HOMETOWN: Randolph, New Jersey

CURRENT NEIGHBORHOOD: Hell's Kitchen, Manhattan

CURRENT AGE: 22

AGE AT TRANSITION: 19

PREFERRED PRONOUN(S): He/him

CAREER/JOB: Writer/performer

RELATIONSHIP STATUS: Single

WHAT WAS YOUR PATH TO TRANSITION LIKE?

There have been some roadblocks in the medical portion, but socially, it's been a long time coming and a very continuous process.

WHAT ARE INTERESTING THINGS ABOUT YOU? WHAT MAKES YOU AS A PERSON UNIQUE?

My love for random facts and details. My creativity. My sensitivity. My sense of humor. My commitment to things that matter to me.

WHAT WOULD YOU LIKE PEOPLE TO KNOW ABOUT YOURSELF AS A TRANSGENDER PERSON THAT MIGHT BE VERY DIFFERENT FROM PEOPLE'S IDEAS OF TRANS PEOPLE?

I was in a fraternity (first out trans man in the world in my specific fraternity).

I'm more than just my trans-ness.

I'm very much a queer/gay man in addition to and in relation to my trans experience.

I'm still very engaged in my religious life.

My masculinity is still evolving, but it's just as valid as the next guy's.

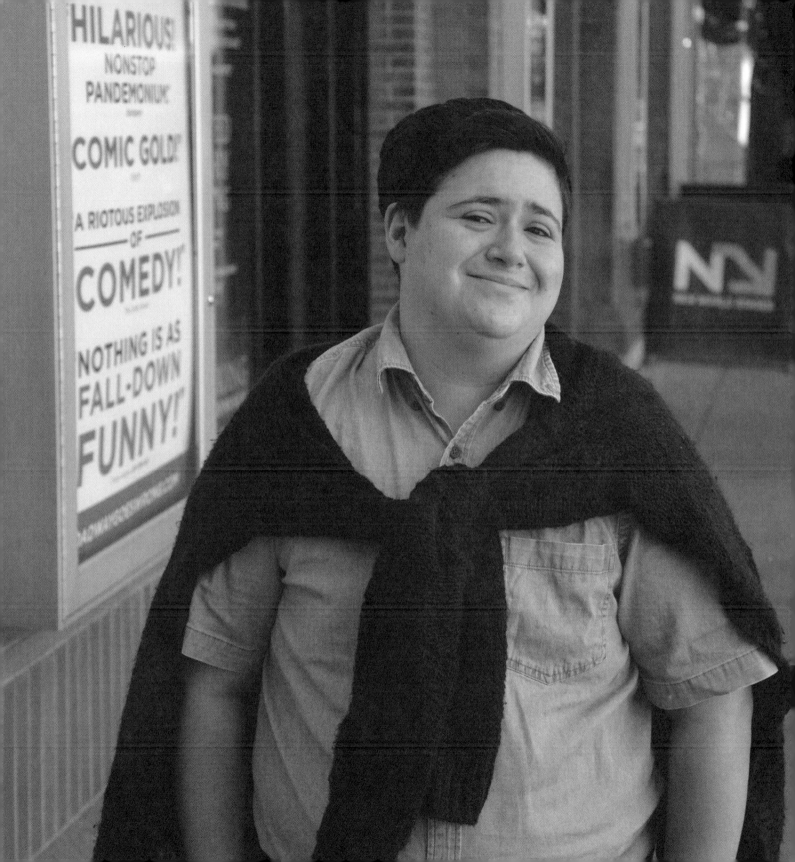

SASHA RODRIGUEZ KOLODKIN

NAME (FIRST AND/OR LAST): Sasha Rodriguez Kolodkin

HOMETOWN: Baltimore, Maryland

CURRENT NEIGHBORHOOD: Bushwick, Brooklyn

CURRENT AGE: 24

AGE AT TRANSITION: 16

PREFERRED PRONOUN(S): She/her

CAREER/JOB: Public advocate

RELATIONSHIP STATUS:

WHAT WAS YOUR PATH TO TRANSITION LIKE?

My path to transition was, by the standards of much of the community today, fairly conservative. I came out around the same time as Laura Jane Grace [lead singer of the punk rock band Against Me!]—this was a few years before trans identity entered our national conversation, which made my process both easier and harder. There is nobody in my life today—besides my family—who knows what I used to look like before my transition, who knows my birth name, or who has seen me naked before I underwent surgery.

When I came out, aesthetics was a major concern of mine. As a transsexual woman who is (somewhat) in the public eye, I recognize the fact that how I look affects many things about me. I want to make it clear: this is not something we are obligated to aspire to and looking good takes work. However, it is work I am proud to be doing. I am vain, and my vanity is a political act.

I saw and still see my transition as a very medical, very clinical process. I understand that many people in the community see their journeys differently and I have the utmost respect for them, but for me? This was correcting something that felt emphatically wrong about my body. I am not going to apologize for this.

WHAT ARE INTERESTING THINGS ABOUT YOU? WHAT MAKES YOU AS A PERSON UNIQUE?

Performance has always been a central part of my life, as a writer and director, and also as a performer. I am, in most aspects of my life, a performer. At night, I perform on stage as an artist. During the day, I perform as the ideal trans person, representing a major LGBT organization. On days off, I've performed

(continued on page 143)

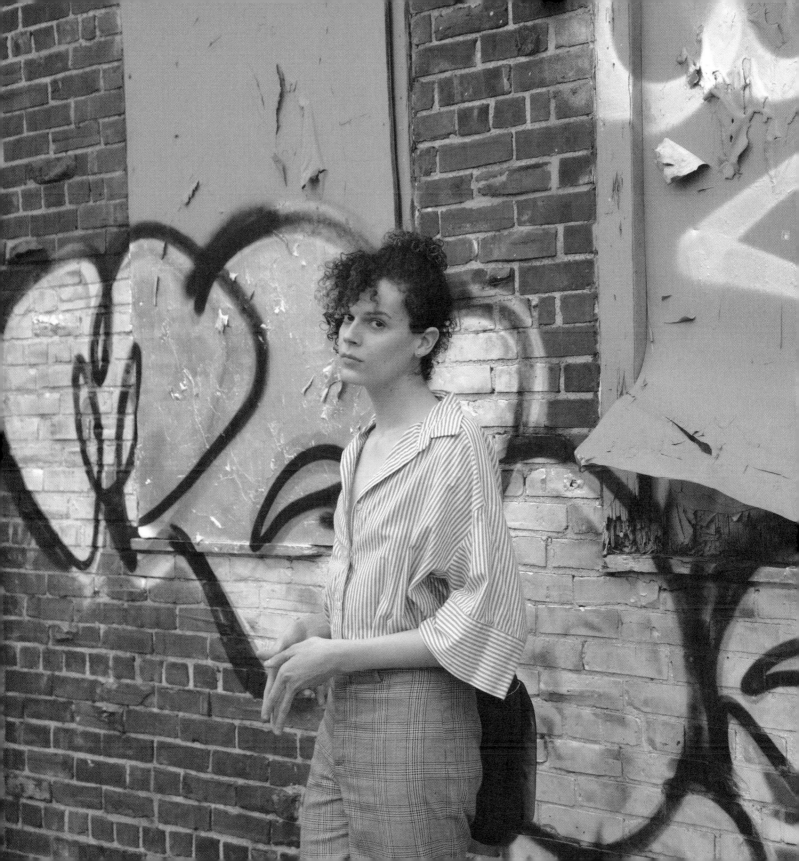

SEBASTIAN FLOWERS

NAME (FIRST AND/OR LAST): Sebastian Flowers

HOMETOWN: Belize and Honduras, Central America

CURRENT NEIGHBORHOOD: Brooklyn

CURRENT AGE: 31

AGE AT TRANSITION: 22

PREFERRED PRONOUN(S): He/him

CAREER/JOB: Actor/model/author/vegan delivery business owner/entrepreneur

RELATIONSHIP STATUS: Single

WHAT WAS YOUR PATH TO TRANSITION LIKE?

I began medically transitioning nearly ten years ago. Sometime after, I became vegan to combat the eye allergies that I'd acquired due to my body rejecting the testosterone cypionate injections (hormone replacement medicine). I decided to clean my body of toxins and start a healthy vegan lifestyle. It worked and my allergies are gone. Two years ago, I had a hysterectomy to affirm my gender, and the complications nearly killed me twice. From 2017 to 2019 I've been learning how to walk, breathe, eat, sit, sleep, dance, and urinate normally. And guess what? I still feel blessed to have been able to transition and live my most authentic life. My health is on the up [and up] and so are my passions. I couldn't be any happier at this moment with transitioning and life.

WHAT ARE INTERESTING THINGS ABOUT YOU? WHAT MAKES YOU AS A PERSON UNIQUE?

I have a large following on social media for my dance moves, ripped physique, acting on *Pose* on FX, and vegan cooking. When people meet me in person, they always say that they admire my ability to stay positive.

WHAT WOULD YOU LIKE PEOPLE TO KNOW ABOUT YOURSELF AS A TRANSGENDER PERSON THAT MIGHT BE VERY DIFFERENT FROM PEOPLE'S IDEAS OF TRANS PEOPLE?

Being an Afro Latino female-to-male trans person has provided me with the ability to feel empathy for all people, but has also given me the strength to materialize my goals without being distracted or offended by others. Because I live in my truth, unapologetically, I am free to be and do all of the things I'm destined to.

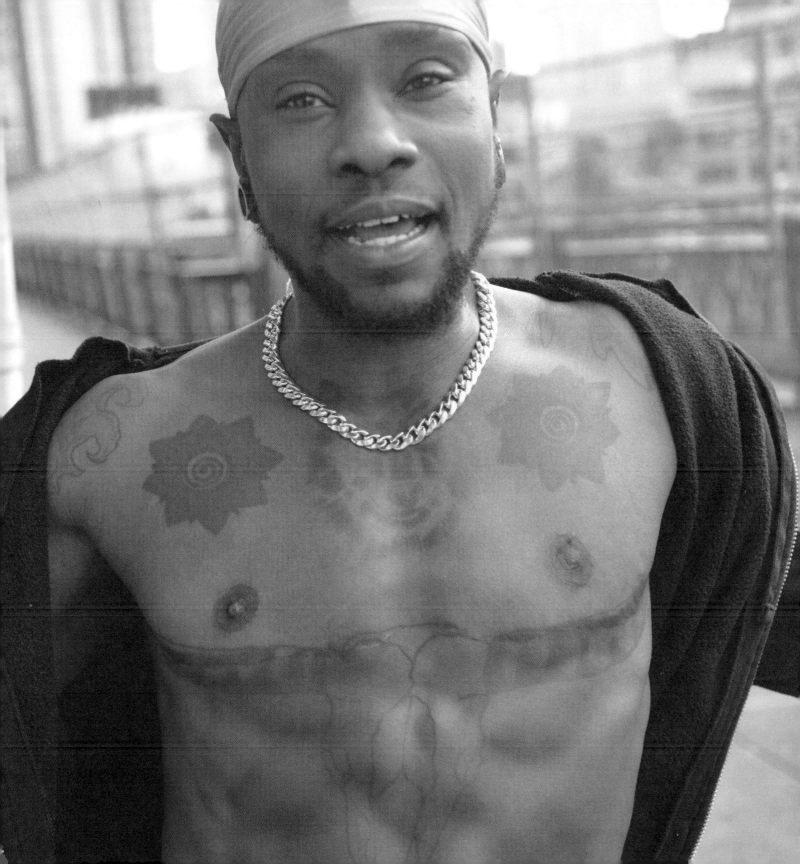

SIMON CHARTRAND

NAME (FIRST AND/OR LAST): Simon Chartrand

HOMETOWN: Boiceville, Ulster County, New York

CURRENT NEIGHBORHOOD: New York City

CURRENT AGE: 27

AGE AT TRANSITION: 22

PREFERRED PRONOUN(S): He/him/his

CAREER/JOB: Former PhD student in French medieval literature, current LGBT activist

RELATIONSHIP STATUS: Partnered

WHAT WAS YOUR PATH TO TRANSITION LIKE?

My path to transition was met with resistance from the outside world. I had to defend my identity in front of everyone, from professors to relatives. I told myself that I wouldn't let myself burn to keep others warm. For me, transitioning was loving myself enough to save myself.

WHAT ARE INTERESTING THINGS ABOUT YOU? WHAT MAKES YOU AS A PERSON UNIQUE?

I was a student athlete and graduated summa cum laude from undergrad. I lived in Paris for a while, studying at the Sorbonne. I was a medievalist for a few years, studying gender nonconformity in French medieval literature. I'm currently working at an LGBT nonprofit, co-facilitating a trans support group. I host trans-focused events, such as clothing swaps. I've switched my focus to the community I'm a part of, and I love every minute of it. I've accomplished all this while being disabled.

For the past four years, following a wisdom tooth surgery gone wrong, I have only had function in half my tongue. I had to teach myself how to speak, how to eat, and how to brush my teeth. I have constant pain in half of my tongue, and no doctor is able to treat it. I was told I would need brain surgery, but after looking at all the complications, I decided to live with the pain instead. I use it to empathize with others.

(continued on page 143)

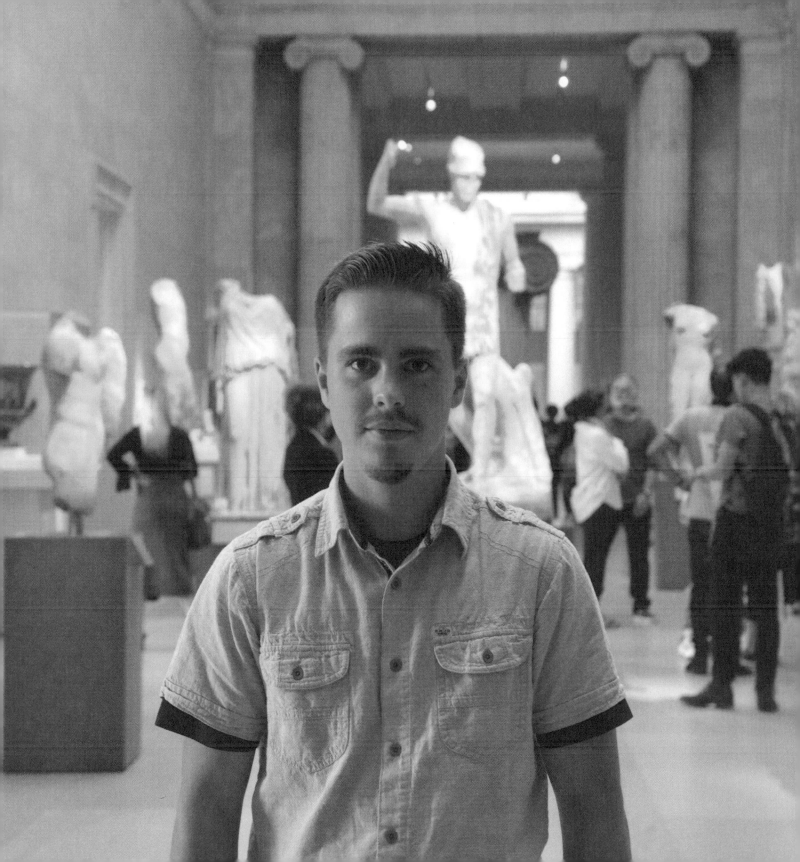

STELLA MAY VLAD

NAME (FIRST AND/OR LAST): Stella May Vlad

HOMETOWN: Lake Carmel, Putnam County, New York

CURRENT NEIGHBORHOOD: Peekskill, Westchester County

CURRENT AGE: 34

AGE AT TRANSITION: 30

PREFERRED PRONOUN(S): She/her/hers

CAREER/JOB: Tattooer

RELATIONSHIP STATUS: Engaged

WHAT WAS YOUR PATH TO TRANSITION LIKE?

That's a loaded question. There's really no short way to respond to that. I would say it's like I lived multiple incongruent roles until coming out/being true to myself.

WHAT ARE INTERESTING THINGS ABOUT YOU? WHAT MAKES YOU AS A PERSON UNIQUE?

I think just being myself makes me unique as a person. We all are unique in our own ways/ways of expressing ourselves.

WHAT WOULD YOU LIKE PEOPLE TO KNOW ABOUT YOURSELF AS A TRANSGENDER PERSON THAT MIGHT BE VERY DIFFERENT FROM PEOPLE'S IDEAS OF TRANS PEOPLE?

I'm easy to talk to and like friendly people. We may have more in common than you'd think! Stop by the shop to chat anytime!

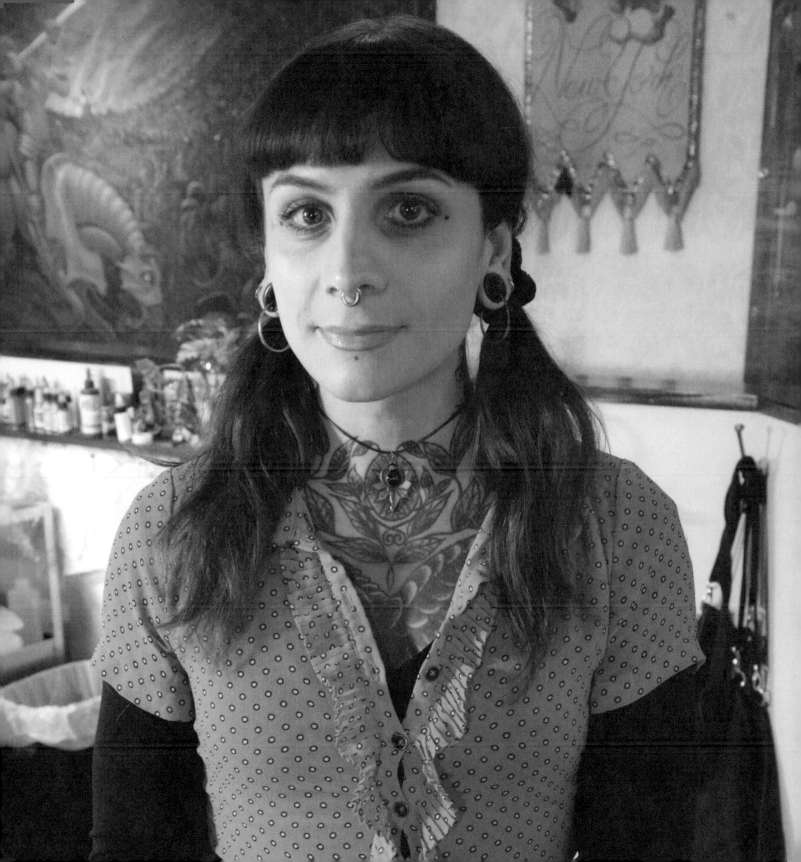

TABYTHA GONZALEZ

NAME (FIRST AND/OR LAST): Tabytha Gonzalez

HOMETOWN: New Jersey

CURRENT NEIGHBORHOOD: Bronx

CURRENT AGE: 45

AGE AT TRANSITION: 24

PREFERRED PRONOUN(S): She/her

CAREER/JOB: Community leader/educator and policy advocate

RELATIONSHIP STATUS: Married to Luis Gonzalez

WHAT WAS YOUR PATH TO TRANSITION LIKE?

My transition is one of many obstacles and trials. To be Afro Latina without an opportunity for higher academia and [facing] discrimination, it was very difficult for me to navigate in certain spaces to become stable. For many years I wanted to blend in for safety, choosing a life of stealth. But today I live in my truth boldly and unapologetically. Becoming a voice for the voiceless has increased my knowledge of myself and given me strength to be me.

WHAT ARE INTERESTING THINGS ABOUT YOU? WHAT MAKES YOU AS A PERSON UNIQUE?

Interesting things about me are that I love all things paranormal and I know how to and love to write gospel. What makes me unique as a person is my ability to empathize with others, and to connect with others easily—that is my gift.

WHAT WOULD YOU LIKE PEOPLE TO KNOW ABOUT YOURSELF AS A TRANSGENDER PERSON THAT MIGHT BE VERY DIFFERENT FROM PEOPLE'S IDEAS OF TRANS PEOPLE?

That I am a God-fearing, loving, nurturing, and family-orientated mother of amazing trans children.

Opposite: Luis Gonzalez (left) and Tabytha Gonzalez (right)

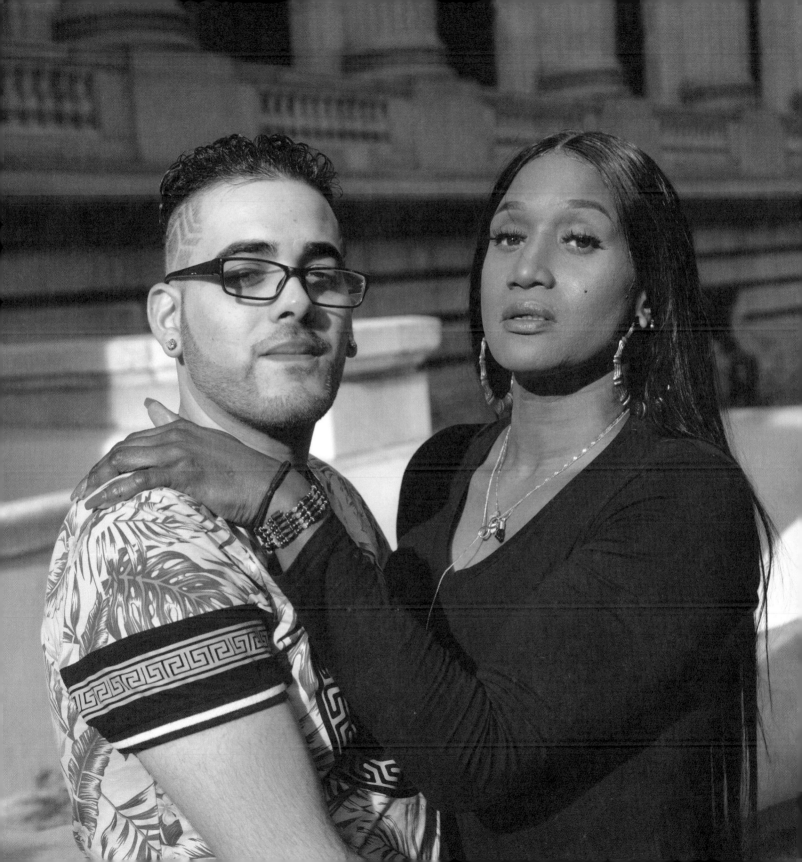

INTERVIEWS CONTINUED

ABBY C. STEIN continued from page 30

And I learned that it's apparently a tradition in my family: when my family doesn't like someone's life choices, they shun them. . . .

I am also a really fast writer. When writing my book, my hard drive was wiped, and I lost 350 pages I hadn't backed up. I rewrote the whole book, over four hundred pages, in under a month! And I learned to always back up my files.

WHAT WOULD YOU LIKE PEOPLE TO KNOW ABOUT YOURSELF AS A TRANSGENDER PERSON THAT MIGHT BE VERY DIFFERENT FROM PEOPLE'S IDEAS OF TRANS PEOPLE?
I hate when people talk about "tolerating" trans people. Tolerance is for lactose, or the weather, not humans. We need to celebrate people, not despite us being trans and/or queer, but because of it. Because it is beautiful! In a big way, I learned that from Judaism, especially from our strong traditions celebrating people and our life cycles.

I *love* being trans, and know that I am a better, happier, and more accomplished person because of it. One of the most common questions I get asked when I speak (I have given over four hundred speeches over the past three years, in over a dozen countries, on four continents) is, "If you could've been born as a cisgender girl, would you choose that?" The answer is no.

ALANA J. DILLON *continued from page 32*

WHAT WOULD YOU LIKE PEOPLE TO KNOW ABOUT YOURSELF AS A TRANSGENDER PERSON THAT MIGHT BE VERY DIFFERENT FROM PEOPLE'S IDEAS OF TRANS PEOPLE?

In some places we (trans) are more accepted than gay people are. If we can be bi-gender, it fits into people's societal model better.

My deepest fantasy is to go through just one calendar year during which my transgender identity is only brought up by me, or by my choice. I relish the thought of a time where I, and all transgender people, can simply exist in the world on our own accord, valued and empowered like those around us are by default. The issue with the resistance to trans people is that it is entirely built on assumption and ignorance. If people gave us the time of day and heard us out, they'd discover that we hold some of the most intuitive and unique stories on the planet. We're not scary. And we don't bite . . . often.

ANGELICA TORRES *continued from page 40*

WHAT ARE INTERESTING THINGS ABOUT YOU? WHAT MAKES YOU AS A PERSON UNIQUE?

I like to think that one of the things that makes me interesting and unique is the fact that I was an activist well before I even knew what the definition of an activist was, or what being an activist entailed. I, along with three others at my high school, was the subject of a documentary entitled *Follow My Voice: With the Music of Hedwig,* which had made its way into the Tribeca Film Festival. I was sixteen years old at the time of filming. At seventeen, I sang backup for the iconic Cyndi Lauper for a cover of "Midnight Radio" made famous by the rock musical film *Hedwig and the Angry Inch.* By the age of twenty-one, I'd filmed two documentaries with MSNBC based around being trans and my involvement with the New York City ballroom scene, and appeared on *The Oprah Winfrey Show* and *America's Next Top Model.* All of this during a time when there was little to no positive trans representation in media.

For most of my life I've never particularly given myself much of any credit for the work I've done in trying to make this world a safer place for my trans

brothers, sisters, and nonbinary family. But within the past year I've learned to be much kinder to myself . . . more empathetic. And I've also learned how to be proud of myself for standing up so strongly in the face of adversity.

WHAT WOULD YOU LIKE PEOPLE TO KNOW ABOUT YOURSELF AS A TRANSGENDER PERSON THAT MIGHT BE VERY DIFFERENT FROM PEOPLE'S IDEAS OF TRANS PEOPLE?

I think this sort of question and conversation goes beyond just me, because all trans people are in some way affected by what stereotypes the general public tends to have of us. With regard to trans women, we're often accused of being sex workers but little do some people realize that many of us have careers outside of the sex trade. Additionally, some trans women pursue sex work as a means of survival . . . not because they want to. There's absolutely *nothing* wrong with sex work, but to make assumptions that we all are sex workers is categorically false.

There are also misconceptions that we as trans people are somehow "misleading" others by not disclosing our trans status from the very beginning of meeting someone, especially when dating. What folks fail to realize is that we are *not* misleading anyone. The same right that cisgender people have to not offer up their entire life stories on the first date should be the same for us. It is hypocritical for cisgender people to expect us to walk around with a scarlet "T" on our foreheads when they themselves are not always forthcoming and honest about their own lives and struggles. It is not our burden to carry if someone else is transphobic. It is not our responsibility or duty to shout from the rooftops that we are trans in order to make others feel comfortable or give space for them to reject us. Not to mention the immense danger that disclosing our trans status can put us in, including death.

As I write this, twenty black trans women (that we know of) have been murdered in the United States this year alone, merely for being visibly trans. Murdered trans women, especially black and brown trans women, are systematically underreported, misgendered in media outlets, and deadnamed [labeled with the name they were given at birth, but stopped using after transitioning] at the times of their deaths. So, there's no way of knowing precisely

how many of us have actually been murdered in this country.

My ask of people when confronting any trans person, whether it be myself or others, is to please leave your biases in the trash where they belong and get to know us beyond our gender identity because there is far more to us than that. Plain and simple.

CHETTINO D'ANGELO *continued from page 50*

WHAT WOULD YOU LIKE PEOPLE TO KNOW ABOUT YOURSELF AS A TRANSGENDER PERSON THAT MIGHT BE VERY DIFFERENT FROM PEOPLE'S IDEAS OF TRANS PEOPLE?
We are human just like everyone else. There is nothing wrong with being transgender. We are loving people who are worthy of love like every other person. We are trying to live freely and authentically in this world. We are very understanding people. Being trans is just as beautiful as being anyone else.

E LEIFER *continued from page 60*

WHAT WOULD YOU LIKE PEOPLE TO KNOW ABOUT YOURSELF AS A TRANSGENDER PERSON THAT MIGHT BE VERY DIFFERENT FROM PEOPLE'S IDEAS OF TRANS PEOPLE?

There is no "one way" or "correct way" to be transgender. There is a spectrum, and trans identity takes many forms. The construct of a binary is artificial. Like any other man-made social construct, strict adherence to the binary was created to dictate and define human validation for the purpose of control.

ERIKA BARKER *continued from page 62*

how to swim, I started my new life as Erika on that following Monday. It was nerve-racking, and I was afraid to make any friends. However, my classmates embraced me and I made a lot of friends. I will never forget how kind everyone was to me back then. In 2014 I moved to New York to embrace my dream of becoming a photographer and was able to get my bottom surgery in 2017.

WHAT ARE INTERESTING THINGS ABOUT YOU? WHAT MAKES YOU AS A PERSON UNIQUE?

I'm an only child who carries the burden of knowing I can't have children now, and I feel incredibly guilty that I can't continue my bloodline and give my parents grandchildren. I know I can adopt, and I probably will one day, but it's a weight on my shoulders that I can never shed.

I'm a proud Navy veteran who took up photography as a career because the mentors I had in the military were so passionate in instilling their knowledge into me. One of them was killed in an IED explosion in Iraq, and I decided to dedicate my career to him.

INTERVIEWS CONTINUED

HEATHER L. GRAHAM *continued from page 68*

WHAT WOULD YOU LIKE PEOPLE TO KNOW ABOUT YOURSELF AS A TRANSGENDER PERSON THAT MIGHT BE VERY DIFFERENT FROM PEOPLE'S IDEAS OF TRANS PEOPLE?

No human being is born the same as the next. I was never a gay man who liked doing things girls liked to do. I was a proud heterosexual. I, however, could never fit into any mold, any cool kids' group, and never had my confidence until I transitioned.

WHAT WOULD YOU LIKE PEOPLE TO KNOW ABOUT YOURSELF AS A TRANSGENDER PERSON THAT MIGHT BE VERY DIFFERENT FROM PEOPLE'S IDEAS OF TRANS PEOPLE?

We're just people. People are people. I believe that once people stop fixating on how different each of our experiences are and just start listening to each other we can actually get some work done.

INTERVIEWS CONTINUED

JOANNA FANG *continued from page 80*

that my "trans-ness" would not null and void my art or destroy my professional career. I had spent my adolescence escaping dysphoria by writing songs and shooting films. Foley is the art of performing sounds for films directly in sync with the characters on screen. It was the perfect combination of sound and image, music and film. I disappeared into the craft and learned how to walk in other people's shoes, reading their body language and embodying the soundtrack of another person's footsteps, clothing, and props. Foley as an art form gave me space to escape my body and my discomfort, but its function as escapism could only last so long.

After five years working as a professional Foley artist, I simply could not shake my dysphoria. I did not choose to be trans, but I did choose to finally take matters into my own hands and transition regardless of the consequence. When it finally came time for me to walk in my own heels down the red carpet, I finally felt like myself. I stopped running away from who I was, and embraced the person I was becoming, the person who represents my best possible self.

WHAT WOULD YOU LIKE PEOPLE TO KNOW ABOUT YOURSELF AS A TRANSGENDER PERSON THAT MIGHT BE VERY DIFFERENT FROM PEOPLE'S IDEAS OF TRANS PEOPLE?
People seem to forget that society's misogyny is ultimately responsible for the cruelty and pain trans people experience. Trans people (especially trans women of color) suffer higher rates of homelessness, unemployment, and violence not because we are trans, but rather because society refuses to accept our basic humanity. The onus is not on trans people to prove their humanity to others; we are not the ones firing ourselves from our workplace, and we are not the ones kicking ourselves out of our homes.

I am incredibly lucky in that I have supportive family members, coworkers, and friends. I live in a community with people who respect me and empathize with who I am without patronizing my trans-ness and the person I used to present as. What makes me different, as a trans woman, is the simple fact that I'm surrounded by support and empathy. I'm proof that trans people can thrive if the community around them offers love and trust over fear and doubt. Everyone in my life recognizes that the most

authentic version of myself is the only acceptable version of myself. Don't get me wrong, I still suffer from depression; I'm still living and struggling with various facets of my own trans experience. However, I can always call home and simply be my mother's daughter. I wish every single trans woman could do the same. My acceptance by my loved ones gives me hope that our society overall has the capacity to be kinder to all trans and gender nonconforming people.

LAURA A. JACOBS *continued from page 90*

WHAT ARE INTERESTING THINGS ABOUT YOU?
WHAT MAKES YOU AS A PERSON UNIQUE?
Unique? I don't know that I am.

My trans-ness is personal, professional, and political. I work with trans and nonbinary people individually as a psychotherapist, and more broadly, I address our issues through public speaking, activism, writing, serving on numerous committees, and as the first trans-identified chair of the Board of Directors for the Callen-Lorde Community Health Center in New York City, one of the largest healthcare providers to trans and nonbinary people anywhere. I try to use my privilege to aid our community.

But I'm also someone "trans feminine" who does female masculinity. I often refer to my gender identity as "dapper." I'm a photographer, former musician, and insist on driving a convertible (sometimes top-down in the rain). I've had an on/off, lifelong relationship with depression. I'm a homeowner. I'm Caucasian and educated. I'm kinky. I'm uncertain about nonmonogamy. And I seem to be in an intimate triad with my couch and *Muppet Show*-themed blanket.

If I have a doppelgänger, let me know.

WHAT WOULD YOU LIKE PEOPLE TO KNOW ABOUT YOURSELF AS A TRANSGENDER PERSON THAT MIGHT BE VERY DIFFERENT FROM PEOPLE'S IDEAS OF TRANS PEOPLE?

I used to think of myself as "born in the wrong bod" or as "meant to be a woman," and that transition was the process of determining which of the two binary categories was most appropriate, then going through the process to shift from one to the other. But now I understand gender to be a facet of the human experience through which we can examine the body, relationships, society, sexuality, power, and even existential questions of meaning.

Though many trans or nonbinary people consider their authentic gender to be innate and just needing to be made manifest, my gender is a choice. I don't know, or care, whether my trans feelings were innate or the result of experience, but I don't see why it matters. I'm here, I'm trans and genderqueer, and it's time society got used to it.

While gender may not be a choice for everyone, it is for me.

MIRANDA MIRANDA *continued from page 104*

Don't give up. It's never too late to start something you've always wanted to do. Life is short and sometimes we don't really know how to fully enjoy it. I'm a very positive person and I know that "wanting is doing." I'm in New York accomplishing my dreams. I'm here to shout to the world, and most importantly to remind myself, that anything is possible if you set your mind to it. Yes.

POOYA MOHSENI continued from page 110

WHAT WOULD YOU LIKE PEOPLE TO KNOW ABOUT YOURSELF AND THE TRANSGENDER COMMUNITY THAT MIGHT BE VERY DIFFERENT FROM PEOPLE'S IDEAS OF TRANS PEOPLE?

I want people to know that like women and men who are not trans, trans women and men are varied. Some choose to have gender affirmation surgery and some don't feel the need. That fact does not make one person more or less trans than the other. Some found safety and community in the ballroom scene and some, like myself, looked for it elsewhere. We come in different colors. We have different jobs, based on our backgrounds, how our families supported us or not, and our own initiative. Some of us identify as straight, meaning we are attracted to people who identify as a different gender than we identify as. Some of us are gay, bi, pansexual, or asexual. Our gender identity is not the same as our sexual orientation. We are not confused. I, for one, knew from a very young age who I was and who I wanted to grow up to be. The world around me was confused, however.

As a trans activist (like most trans people I've met), I like to educate people about gender and sex and the difference between the two. Not because anyone is entitled to an explanation, but because the more people know facts, the less likely they are to say or do something that is fueled by ignorance and fear, and that makes for a better world.

I also believe that all of us—women, men, people of color, trans women and men, the gay and lesbian community and beyond—are fighting for the same things: equal personhood and the safety, security, and societal participation that comes with that equality. I'm a trans immigrant person of color who believes in a better tomorrow, where our race, sex, gender identity, religion, sexual orientation, and nationality won't define who we are, but our actions will. And while this better world may not come to be in my lifetime, I find great solace in the fact that my words, thoughts, and actions, along with [those of] millions of others, will incrementally bring us closer to that better future . . . and that is my purpose for living.

PRESTON ALLEN *continued from page 112*

WHAT WOULD YOU LIKE PEOPLE TO KNOW ABOUT YOURSELF AS A TRANSGENDER PERSON THAT MIGHT BE VERY DIFFERENT FROM PEOPLE'S IDEAS OF TRANS PEOPLE?

There's nothing about the trans part of my identity that can inform anyone about who I am. Whatever blanket "idea" someone might have about my community is something they've entirely made up. I don't do cisgender people the disservice of assuming anything about them or their bodies. I learn what I know about someone from talking to them, listening to them, and seeing how well they listen to me. Being trans is a very small part of my identity, but it's also one I'm very proud of, that has saved my life, and that I will continue to be loud about the normalcy of as long as so many people—especially in the government—try to make it this big deal. It's not. I'm a cat dad who loves Regina Spektor, watches too much TV, and needs to clean his room. I've held the elevator for you and you've opened a door for me. We all deserve to move on safely with our lives.

RAYNE VALENTINE *continued from page 116*

WHAT WOULD YOU LIKE PEOPLE TO KNOW ABOUT YOURSELF AS A TRANSGENDER PERSON THAT MIGHT BE VERY DIFFERENT FROM PEOPLE'S IDEAS OF TRANS PEOPLE?

I'd like people to know that transitioning is hard. Beyond hard. It's brutal, mentally especially. That the support of even one person close to us can ease that difficulty, and make it that much easier. People have this notion that [being trans] is a phase or a fad, and it isn't. It's something that we struggle with every day, and not every person can transition. So, something as simple as respecting pronouns, regardless of how one looks, or presents, means the world. It's rough out here, and people like me and my fellow trans brothers and sisters have enough to go through. Just be an ally and show a little kindness—you never know someone else's battle.

SASHA R. KOLODKIN *continued from page 122*

for my community at the UN [United Nations], or at City Hall, or at a protest. And I feel the need to stress: this only has to do with my trans identity, insofar as trans identity is what I am performing. Performance is a political act.

WHAT WOULD YOU LIKE PEOPLE TO KNOW ABOUT YOURSELF AS A TRANSGENDER PERSON THAT MIGHT BE VERY DIFFERENT FROM PEOPLE'S IDEAS OF TRANS PEOPLE?

I don't hate cisgender people. Most of my friends are cis, and most of the people on Earth are cis. I find our tendency to distrust and despise people who do not share our experiences counterproductive at best, and self-destructive at worst. Someone with a significant amount of power at a leading humanitarian organization once asked me what made me feel included as a trans person. I answered, "I feel included as a trans woman when I, a trans woman, am in the room being included." I believe there's a place for me in the larger world.

SIMON CHARTRAND *continued from page 126*

WHAT WOULD YOU LIKE PEOPLE TO KNOW ABOUT YOURSELF AS A TRANSGENDER PERSON THAT MIGHT BE VERY DIFFERENT FROM PEOPLE'S IDEAS OF TRANS PEOPLE?

Nobody really expects me to say I'm interested in being pregnant one day. As a man, that's important to me. Pregnancy, abortion, and general ob-gyn services aren't just for cis women. Body parts don't determine gender identity.

I identify as bisexual, but oftentimes people don't realize I'm attracted to men as well as women and nonbinary people. My current partner is a cis gay man.

Lastly, one important thing to me is that people don't see me as an object of fascination. I, like many other trans people, need to be treated as a human individual. We have likes, dislikes, etc. Nothing I can say or do makes me anything other than human.

Thank you to all of the people who contributed their amazing stories to this book. Special thanks to Abby Stein, Pooya Mohseni, Jevon Martin, and Grace Detrevarah for their writing; Camilla Vazquez for allowing me to use her photo on the cover; Birgitte Philippides-Delaney and the Trans Beauty Clinic; and Julia Abramoff at Apollo Publishers.